Museum Notes are produced with the assistance of
the Leon and Thea Koerner Foundation
and the Anthropology Shop Volunteers

This book has been published with the
assistance of the Canada Council.

Cover: Toward Totem by Jack Shadbolt
from the collection of the UBC Museum of Anthropology

End papers. Jack Shadbolt in his Burnaby studio, 1985.
The three unfinished paintings are (from left to right):
Coast Memory IV (figure 29), **Bird Spirit** (upside down;
figure 40), and the centre panel of the triptych **Silent
Land** (figure 41).

Jack Shadbolt and the Coastal Indian Image
© The University of British Columbia Press 1986
all rights reserved
International Standard Book Number 0-7748-0262-6

Canadian Cataloguing in Publication Data

Halpin, Marjorie M., 1937—
Jack Shadbolt and the Coastal Indian Image

 (Museum note, ISSN 0228-2364; no. 18)
 Bibliography: p. 55
 ISBN 0-7748-0262-6

1. Shadbolt, Jack, 1909- 2. Indians
of North America — Northwest Coast of North
America — Art — Influence. I. Shadbolt,
Jack, 1909- II. University British
Columbia. Museum of Anthropology III.
Title. IV. Series: Museum note (University
of British Columbia. Museum of Anthropology);
no. 18.

ND249.S53H34 1986 759.11 C86-091371-6

Museum Note Design: W. McLennan Printed in Canada

Jack Shadbolt

and the Coastal Indian Image

Marjorie M. Halpin

Foreword by Michael M. Ames

Museum Note No. 18

University of British Columbia Press
in association with
the UBC Museum of Anthropology

Vancouver

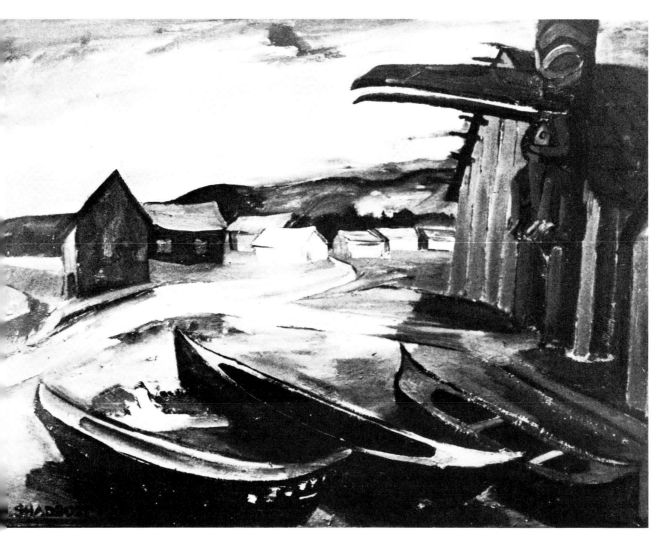

Figure 1. **Indian Village**, 1948. An example of
what Shadbolt calls the *external view*, or the
way things appear to the eye, which he
contrasts with *the Indian mode of expressing
things from inside out* (see the entry from his
journal on p. 26).

Foreword

What **is** Jack Shadbolt doing in the Museum of Anthropology? Artists usually have their works displayed in galleries, but here is Shadbolt, one of Canada's best known artists, exhibited in a museum. The reason is simple enough. Just as Shadbolt appropriated Indian themes and images for many of his paintings, so here a curator of anthropology has appropriated Shadbolt and, with him, the world of art criticism.

Dr. Marjorie Halpin provides for Shadbolt's work both the general art historical context of the movement in modern art known as primitivism and the specific social context of evolving Indian/non-Indian relations in British Columbia. Along the way, she also guides us to a better understanding of our own ambivalent relations with the exotic that are represented here by the Coastal Indian image—how what appears alien to us is also a necessary part of who we are. *It is, in fact,* Halpin quotes Thomas Berger, *in our relations with the people from whom we took this land that we can discover the truth about ourselves and the society we have built, and gain a larger view of the world.* We learn, then, how Shadbolt's *acts of art* express this critical relationship between the other and ourselves, raising its analysis to a refined artistic dimension.

Jack Shadbolt and the Coastal Indian Image has been published in association with Dr. Halpin's exhibition of the same name that opened at the Museum of Anthropology on 17 June 1986. It may also be seen as a companion volume to Karen Duffek's **Bill Reid: Beyond the Essential Form**, an analysis of that famous Haida artist's work. Halpin and Duffek both contribute to the development of a critical language that encompasses within one understanding Reid and Shadbolt, "primitive" and modern art, and that continuous tacking back and forth between the particularity of origins and the generality of appeal that character-izes fine art everywhere.

The publication of this book was assisted by a grant from the Canada Council. The purchase of the painting on the cover, **Toward Totem**, was made possible by the Department of Communications Special Grant-ing Programme for Vancouver to Celebrate the City's Centennial. Museum of Anthropology exhibition programmes are also supported by the Museums Assistance Programmes of the National Museums of Canada and the Cultural Services Branch and Lottery Fund of the Government of British Columbia. The Museum Note series is assisted by the Leon and Thea Koerner Foundation and the Anthropology Shop Volunteers. We also thank Jack Shadbolt and Doris Shadbolt for their service and assistance.

Michael M. Ames
Director, Museum of Anthropology

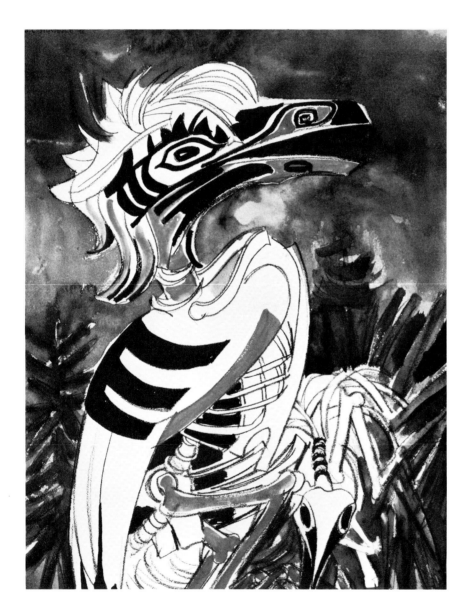

Figure 2. **Killer Birds**, 1948-study. This paint-
ing is one of a series of watercolours that
mark the beginnings of the stylistic influ-
ence of Indian art on Jack Shadbolt's personal
mode of abstraction.

Contents

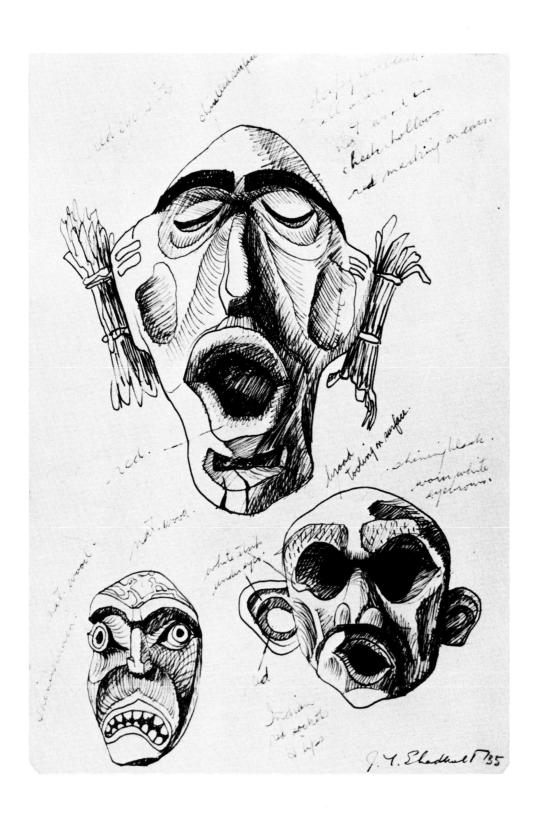

The problem is,
what do you do for a past
if you are white,
relatively new to the continent
and rootless?

Margaret Atwood

Introduction

As an expressionist painter, Jack Shadbolt works to let *something* flow from or through him unimpeded by what he calls *cerebral dictation* or conscious planning. Shadbolt has referred to that something as life's programming: expressionist art theory identifies it as the unconscious, while I have the anthropologist's interest in the shared patterning of behaviour, often nonconscious or preconscious, that can be attributed to culture.

This book and the 1986 exhibition on which it is based, **Jack Shadbolt and the Coastal Indian Image** at the UBC Museum of Anthropology, deal with only one theme in this complex and prolific artist's work, but it is a theme that has persisted throughout his

Figure 3. A 1935 sketch of two Kwagiutl masks and a Hamatsa rattle in the B.C. Provincial Museum in Victoria. This rattle inspired Shadbolt's 1948 painting, **Image with Red Bones** (figure 12). Sketch not exhibited.

career: the earliest image in the book is a drawing of a Southern Kwagiutl rattle from 1935 and the latest a series of paintings from 1985-86, a half-century later.

Shadbolt's Indian paintings make sense to me, an anthropologist, in two contexts, and it is the alternations between these that suggested the form of the present essay. The first is the generalized movement in art known as primitivism, especially as it developed in the New York of the 1940s, and the second the local relation of Shadbolt with his predecessor Emily Carr, particularly as they reflect the history of Indian/non-Indian affairs in British Columbia. Shadbolt himself talks of his work in terms of international art history. When his paintings are viewed against the background of what has been happening locally between Indians and non-Indians, however, they make a new and compelling kind of sense, and can be read as a visual record of an evolving relation with Indian society, a record that reveals aspects of the social role of the artist.

The artist's *job*, writes Margaret Atwood, poet, novelist, and critic of Canadian literature, is *articulating the community, or (to put it another way) creating satisfying structures out of the materials at hand.*[1] In a 1985 conversation, Shadbolt said that he hoped he was *good enough an instrument* to transform his experience into paintings that resonated in the experience of others. His sustained popularity over the years suggests that he has been such an instrument, or medium of communication, for the forming and expression of community awareness. Not only has he been successful by the popular yardstick of sales, but he has also been honoured by the academy, receiving doctorates from the universities of British Columbia, Simon Fraser, and Victoria, the Canada Council Molson Prize, and the Order of Canada, as well as being the subject of many prestigious exhibitions. In another sense, he is the academy, having been the head of the Drawing and Painting section of the Vancouver School of Art from 1945 to 1966.

Shadbolt is not a political artist in the narrow meaning of this term: he neither comments on nor portrays events in the real world. He recalls that, though he was *worked on steadily* in the 1930s by his *socially conscious friends, most of whom were pro-Marxist,* to become an *artist for the workers* and *engage in the struggle,* the nearest he *ever came to an art linked to the actuality of events* was a series of World War II drawings which he entitled **The Occupation of Point Grey.** They showed an imaginary Japanese occupation of the *carefully documented locations of* [*his*] *own immediate neighbourhood.*[2] Shadbolt paints landscapes of the imagination that are tied more or less loosely to forms of nature and artifacts. The social power of his work, and probably its aesthetic power as well, operate at a level deeper than ideology or cognition. From my own perspective, however, his primitivist paintings, or those works which "cite" or refer to artifacts from various exotic and tribal cultures, are most assuredly political, as I will try to show.

In the two years of planning that preceded the Museum of Anthropology exhibition, Shadbolt produced a series of images with direct or overt political content, his first since the war. These 1985-86 paintings have surprised the local art community, who expect his work to be more "painterly," more about art itself than events external to the act of painting. Perhaps it was the prospect of an exhibition at the museum that sensitized him; perhaps it was the book on the Haida artist Bill Reid that his wife, Doris, was writing at the same time; perhaps too, as I suggest here, it was the new relations developing between British Columbians and the Native people of this province.

The shapes of knowledge, writes anthropologist Clifford Geertz, *are always ineluctably local.*[3] Northrop Frye, Canada's premier cultural critic, observes that *the artist seems to draw strength from a very limited community.... The more intensely Faulkner concentrates on his unpronounceable county in Mississippi, the more intelligible he becomes to readers all over the world.*[4] Jack Shadbolt's Indian paintings are so evocative of this particular place on the globe, and of its unique cultural vocabularies and contradictions, that they seem especially appropriate images to present during 1986, the year of Vancouver's centennial celebration of itself as a city and of Expo 86, a world's fair drawing international visitors to British Columbia.

All the Indian artifacts that inspire Shadbolt are museum pieces, excellent examples of, for the most part, late nineteenth-century Indian art. They are frozen in time, unchanging: what does change is the way he responds to them.

Normally, museums exhibit Coastal Indian artifacts using anthropological reconstructions of their original cultural context. This has the unintended consequence, especially when it is seen in museum after museum, of implanting the notion that "real" Indians somehow disappeared in the late nineteenth century. Anthropological reconstructions of Indian cultures also evolve over time, reflecting changing theoretical concerns, changing relationships between scholars and Indians, and changing conditions in Indian societies. **Jack Shadbolt and the Coastal Indian Image** permits the Museum of Anthropology to reveal other uses for museum objects than those current when they were collected. Against their now timeless presence and authenticity, the artifacts permit us to view our own evolving relation with those who are culturally Other and yet so much a part of us.

1. Margaret Atwood 1972:192.
2. Jack Shadbolt 1975:22.
3. Clifford Geertz 1983:4.
4. Northrop Frye 1982:4.

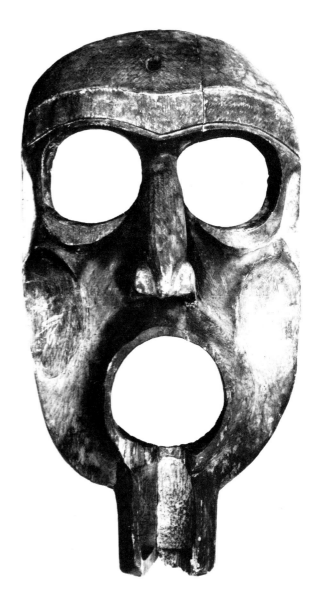

Figure 4. Head of Dzonokwa (Wild Woman of the Woods), Southern Kwagiutl.

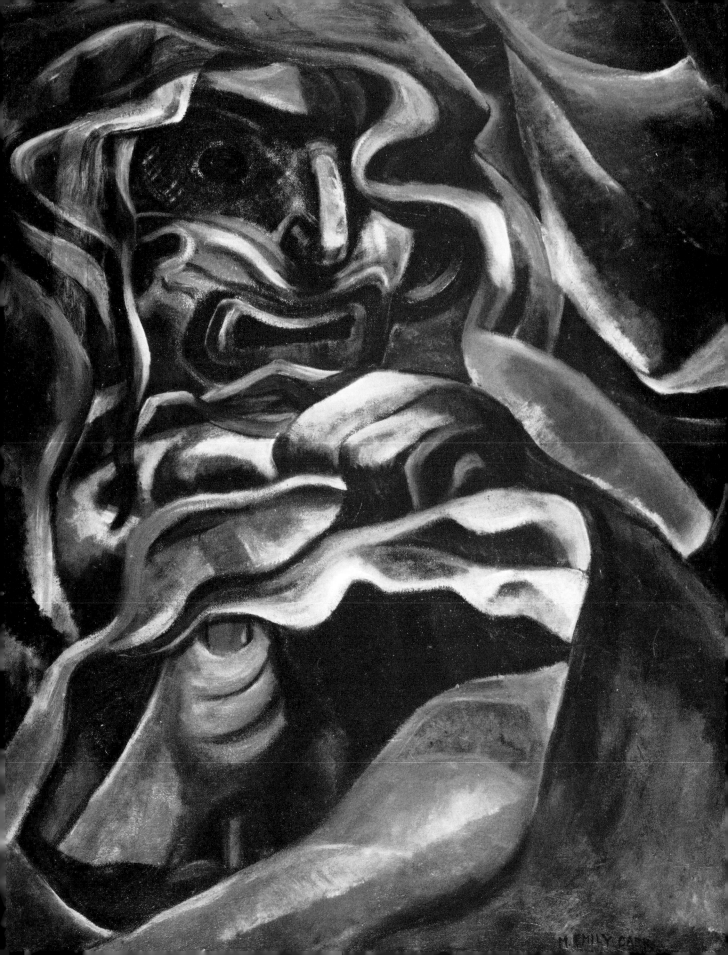

In Search of Freedom

Jack Shadbolt uses Coast Indian imagery in his work as *the nearest symbolic mythology to hand*, and because he was *originally fired* by contact with Emily Carr's *powerful and brooding evocations of tragedy* in her paintings of Indian villages (journal entry, p. 25). He also acknowledges Indian art as *my final clue to releasing my drawing, through design, from European bondage to the external view*—that is, painting the way the surfaces of things look to the eye. This section traces his pursuit of that freedom.

Shadbolt, who was born in England in 1909 and raised in Victoria, recalls painting with his father, an amateur who copied scenes from calendars. He traces the beginnings of his career as a serious artist to the year 1927, when he began sketching the Victoria area with his friend Max Maynard.[1] Probably in 1930, Maynard introduced him to Emily Carr, and he fell under the spell of her art and personality. In 1968 he wrote that the most compelling influence for an artist is *to come under the immediate spell of a famous artist one admires tremendously and, at the same time, encounters personally in one's own local community, working from the same sources as oneself.* He acknowledged both Carr and F. H. Varley, from whom he had later taken a night-school course in Vancouver, as just such influences in his life—artists who, in his admiring perception, *walked clothed in magic.*[2]

Emily Carr (1871-1945) was born in Victoria of English parents and began her commitment to painting Indian themes during a 1907 trip to Alaska. Afterwards she travelled elsewhere on Vancouver Island, to Alert Bay, the Queen Charlotte Islands, and up the Nass and Skeena rivers, visually recording Indian villages and totem poles with the urgency of a salvage anthropologist. In her autobiography, Carr[3] writes that *Indian art broadened my seeing, loosened the formal tightness I had learned in England's schools* [*in Victoria*]. *The Indian caught first at the inner intensity of his subject, worked outward to the surfaces. His spiritual conception he buried deep in the wood he was about to carve.** However, as Doris Shadbolt observes, *Carr's understanding of Indian art is not in fact reflected in her work until after 1927 when she strips the poles of excessive detail, removes them from distracting settings and concentrates on their sculptural strength and expressive energy.*[4]

Carr's ethnographic concern to represent Indian forms faithfully thus *acted as a curb* on her purely artistic development. After exposure to Post-Impressionist painting in France, where she studied in 1910-11, however, she developed a brilliant palette and a *painterly manner* that were to mark *her entry into the central stream of twentieth-century art* and end her credibility as a ethnographic illustrator. Carr's newly acquired French style was, in fact, *at odds with her avowed task of recording totem poles in their native settings.*[5]

Figure 5. **Strangled by Growth**, 1931. Oil on canvas, 63.5 x 48.3 cm. One of Emily Carr's late Indian paintings reveals her belief that Indian artifacts are organic expressions of the coastal forest. Photograph courtesy the Vancouver Art Gallery.

*Compare Carr's statement with Shadbolt's 1985 journal entry (see p. 26 below) that *the Indian mode of expressing things from inside out, out of deep interior identification with the spirit of the image portrayed, gave me my inventive impetus as well as helping me to my personal mode of abstraction.*

Another turning-point in Carr's development came when in 1927, a few years before Jack Shadbolt met her, she travelled east to attend the opening of *Canadian West Coast Art: Native and Modern,* an exhibition arranged jointly by Eric Brown, director of the National Gallery, and Marius Barbeau, an anthropologist with the National Museum. Their purpose was to *mingle for the first time the art work of the Canadian West Coast tribes with that of our more sophisticated artists.*[6] Carr was the most-represented artist in the "modern" section, which included paintings by Lawren Harris, F. H. Varley, Langdon Kihn, A. Y. Jackson, and Edwin Holgate. The modern paintings were portraits, village scenes, and landscapes used to create context for Native masks, sculptures, rattles, and other artifacts from the National Museum.

Of far more importance to Carr than the exhibition itself was meeting the eastern artists of the Group of Seven, especially Lawren Harris. *Both Harris's concept of painting as reflecting metaphysical-spiritual states of being and his specific pictorial devices were to have a strong influence on Carr over the next couple of years.*[7] It is at this point that her paintings begin to reflect the style of Indian art, something that had taken thirty years to achieve.

Emily Carr travelled by foot, boat, canoe, and horse to sketch and paint Indian totem poles and villages in their natural settings. Jack Shadbolt sketches in museums and paints museum artifacts from books. This shift in venue seems to reflect more than just differences of individual temperament.

Museumized cultures exert little influence on their environment—the presence of Indian artifacts in a museum suggests that the connection with human life has been broken, and they can now be romanticized freely by strangers. By the time Shadbolt met Emily Carr in 1930, the Indian population in British Columbia was at its lowest ebb. The distinctive material culture had been largely replaced by manufactured goods, with the Native artifacts shipped off to museums, and it was generally believed that the assimilation of the remaining deculturalized and demoralized aboriginal peoples was now inevitable. This was still assumed to be the case by anthropologists working in the region as late as 1960. Hawthorn, Belshaw, and Jamison state in their book, **The Indians of British Columbia**: *Our research takes it as axiomatic that the acculturative change of the Indian is irreversible and is going to continue, no matter what is done or desired by anyone.*[8]

It was against this background of vanishing Indianness that Shadbolt did his *first serious drawing* of Indian artifacts in the Provincial Museum in Victoria (figures 3 and 17). He also sketched on the Cowichan Indian Reserve near Duncan on Vancouver Island, where he took his first teaching job. But it was not until he too had studied in London, Paris, and New York, been touched by the horror of war in the England of 1944-45, and returned in 1947 to sketch animal skeletons in the museum in Victoria, that a significant influence from Indian art began to show up in his style. Like Carr before him, he had to become a working artist himself before he could recognize what the Indian artists were up to and respond to it in any deeper way than mere appropriation of subject matter.

Figures 6, 7. **Indians Outside a Village**, 1944. This painting shows Shadbolt's pre-1947 use of Indian themes. It also reveals his lifelong tendency to combine images from various sources. The village scene was sketched on the Cowichan Indian reserve near Duncan and the people were copied from a photograph. Photograph courtesy the British Columbia Provincial Museum. Painting not exhibited.

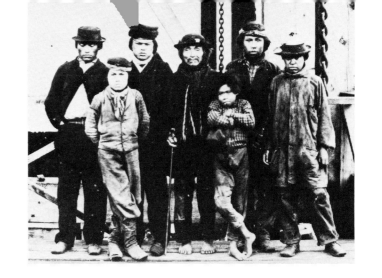

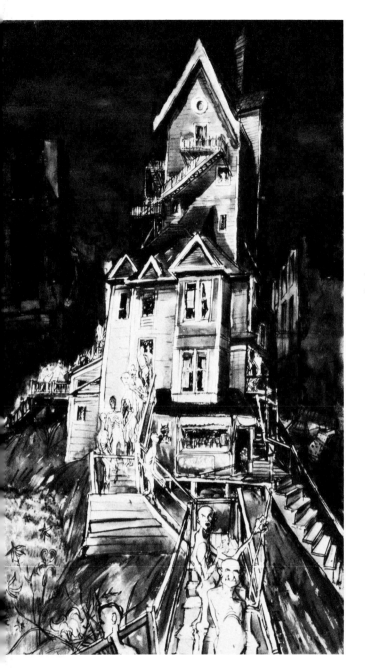

During the war, Shadbolt saw and catalogued army photographs of concentration-camp victims and learned that *bombs can abstract a building very quickly: It suddenly dawned on me, about this business of abstraction.... And it is this, that when the bomb blows the building apart it abstracts it, the pieces fall back together again and you get a memory image of what was there but vastly altered and psychologically made infinitely more intense than the original thing.*[9] When he returned to British Columbia, he was looking for a new and non-literal way of exorcising the war: *I found the experience devastating. For some time after this I had need for a violent image of pathos to relieve my feelings, in my work, of this traumatic revulsion and to express my outrage.*[10]

Figure 8. In **House at the End**, 1946, prisoners of war emerge from a Robson Street dwelling in Vancouver. At this time, Shadbolt is still attempting to image "pathos" in a documentary manner. Painting not exhibited; photograph courtesy Jack Shadbolt.

Figure 9. **Dog Among the Ruins**, 1947. This striking watercolour is one of a series of postwar works in which Shadbolt used dogs to express the pathos of the human condition. Painting not exhibited; photograph courtesy Jack Shadbolt.

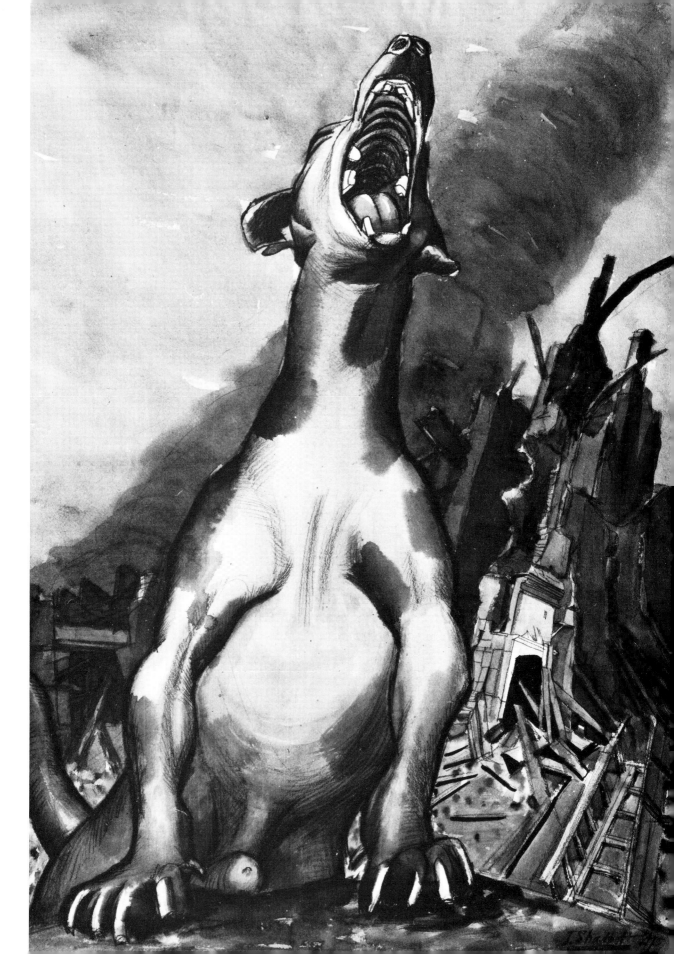

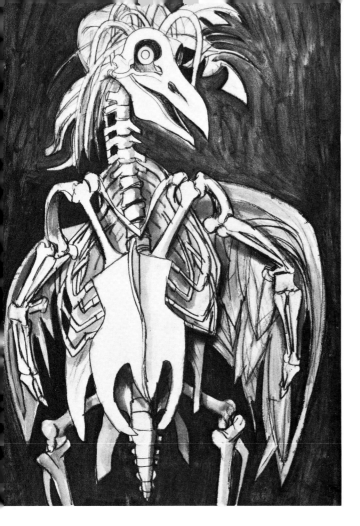

Figure 10. **Bird Image**, 1948. Shadbolt (1968: 40) calls this an *image of pathos*, and writes of it that *there is nothing more ultimately pathetic than an old person stripped of vanity and still trying to maintain a manner of dignity.... It seemed to me that this gaunt, absurd, posturing, truly naked image, treated in ironic, decoratively ornamental gaiety like an old crone parading her tattered finery, had a certain touching effectiveness. Here the skeletal parts are primarily arranged for their emblematic design values.*

By this time, Shadbolt knew that he was an artist and a technically good one. He could draw and paint from life as well as *any commonplace Renaissance master*, but *still didn't know who [he] was*. He had not yet developed his *own set of forms*, his own *familiars*. Like Carr, he had to find a place for himself in the main stream of contemporary art. He could not simply take over her territory, which he identifies as *the Forest and the Indians* and the *tail end of Cubism* that she absorbed from Lawren Harris and Mark Tobey of Seattle. *What I had to learn, to go through, was a new attitude toward pictorial structure that developed after Cézanne*. He is referring here to the abandonment of the illusion of depth in painting in order to work directly on the surface of the picture plane: Cézanne marks the *turning-point* in the shift from perspectival

space to a created space of shapes and colours. *The long process,* he told students at a 1986 lecture at the Museum of Anthropology, *is to get it from your head into your gut.*

Shadbolt did know by 1945, however, that *my roots were here* and that he must define his own authenticity as a regional artist: *I would feel lost, and I did feel lost, if I were away from that wilderness edge*. It is significant that, while Carr claimed the wilderness itself as her territory, Shadbolt claims its *edge*, saying that he is always interested in the *manmade drama against wild nature*. His imagination is fed by the knowledge that there is still uncharted territory both *out there* and *inside oneself*. From Indian art, he would learn a new relationship between inside and outside that he adopted as his own.

When, in 1947, he returned to the Provincial Museum, he was still in pursuit of a pictorial language with which to convey the horror of war. *By this time I found it totally impossible to say anything direct with the [human] figure. It is such a treacherous image, you are either into realism or you're into graphic melodrama or you're into just sensuous anatomy.... I wanted to say something about the human condition, but...I couldn't find it in a direct way.*[11] Shadbolt turned to sketching and painting animal and bird skeletons in order to tap what he later described as *skeletal power*. He learned that he could *transpose from anatomical structure into*

design with no effective loss of imaginative impact, providing the one key factor is retained—a sense of articulation. If one part of the design moves, another must respond.[12]

At the same time, he grasped new possibilities for expressing emotion through Indian masks and other artifacts. **Red Knight** (figure 18), **Image with Red Bones** (figure 12), and the **Killer Birds** watercolour series (figures 2, 14-16), which he acknowledges as marking his *first intense relationship* with Indian art, were painted in 1947-48 after the trip to the Provincial Museum. Although he had drawn Indian masks often before, he now *suddenly realized* that they were *full of force*.[13] In a 1985

catalogue, Vancouver Art Gallery curator Scott Watson recognized the connection between these paintings and Shadbolt's wartime experience: *It is not a mere irony that the sight of the branded victims of the Nazis set all this in motion. Rather, it may have been from this source that Shadbolt came to realize that the decorative has the power it does to enunciate and contain horror.*

Figure 11. **Victim**, 1947. Shadbolt's 1947 discovery of the expressiveness of *skeletal power*, which was triggered when he saw an animal skeleton on the beach at Hornby Island, was an important step in his abandonment of perceptual art. Painting not exhibited; photograph courtesy Jack Shadbolt.

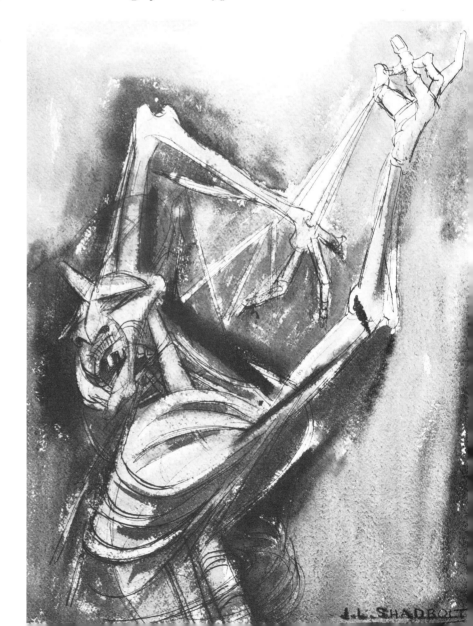

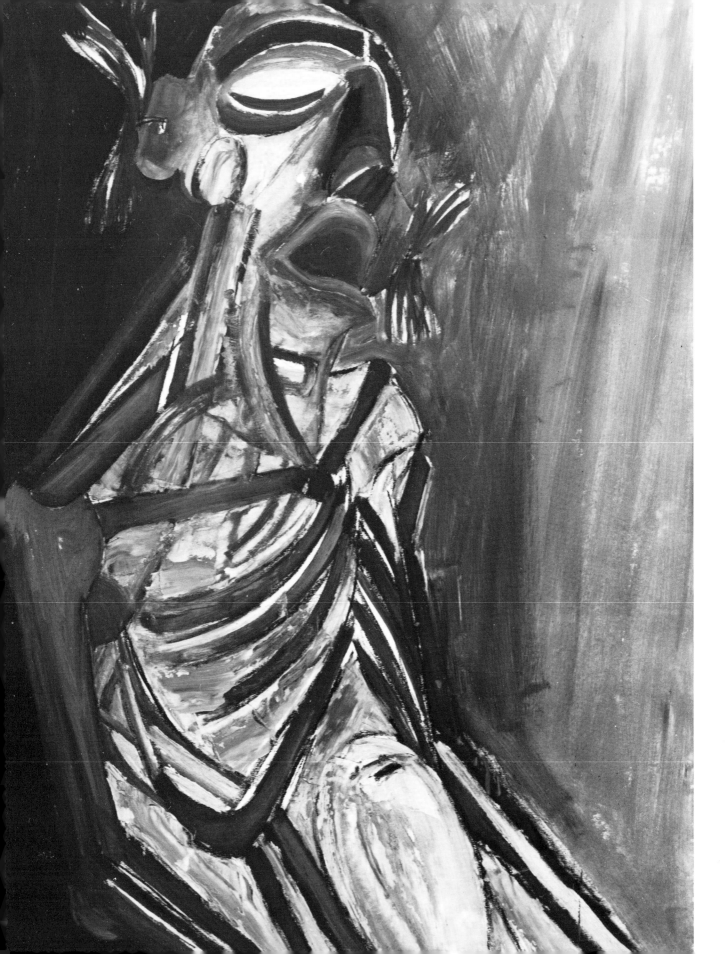

Figures 12, 13. Comparison of 1935 drawing of a Southern Kwagiutl Hamatsa rattle (figure 3) in the British Columbia Provincial Museum and **Image with Red Bones**, painted in 1947, reveals Shadbolt's use of images in his sketchbooks and his more expressive postwar use of Indian artifacts. Pathos is no longer imaged in a documentary manner here. The Museum of Anthropology's "Sneezer" mask (also not exhibited) has a provocative similarity with the image in the painting. Painting not exhibited; photograph courtesy Jack Shadbolt.

Image with Red Bones, an especially compelling painting, uses a 1935 drawing of a Southern Kwagiutl Hamatsa rattle that figured originally in the ritual taming of an initiate possessed by the spirit of the Man-Eater-at-the-north-end-of-the-world: a human is shown by Shadbolt with the agonized face of one seemingly trapped in his own skeleton—a combination of skeletal power and an Indian image of death. The masks that Shadbolt puts on his avian skeletons are those of giant, maneating birds, associates of the monster Man-Eater-at-the-north-end-of-the-world. His insight that one can tame emotional fear by placing a pattern over it, which he attributes to his encounter later that year with Picasso's *psychological abstraction*, must be prefigured in the choice of the Hamatsa mask and rattle for these 1947-48 paintings. One cannot overlook the possibility, especially in the light of Picasso's own awakening to African sculpture in the Paris Trocadéro Museum (now the Musée de l'Homme), that Shadbolt also intuited if not consciously recognized at this time the relation between tribal masks and exorcism of the fear of death.

When Picasso incorporated aspects of tribal art into his own style in 1907, he too was looking for a way to communicate *primordial fears,* in his own case fear of death by disease.[14] In other words, for Picasso as for

Shadbolt, the original encounter with tribal art did not influence his style as a painter until the artist confronted death and was ready for its exorcism through his art. Picasso was later to call his **Demoiselles d'Avignon,** the painting he was working on at the time of his transformation under the influence of African sculpture, *my first exorcism picture.* The words he *used and reused* in describing his experience in the Trocadéro's African gallery— *shock, revelation, charge,* and *force*—make it clear, according to William Rubin, *that he had experienced both a trauma and an epiphany.*[15]

For me the masks were not just sculptures, Picasso told André Malraux: *They were magical objects…intercessors…against everything—against unknown, threatening spirits. They were weapons—to keep people from being ruled by spirits, to help free themselves…. If we give a form to these spirits, we become free.*[16] Rubin sees this statement as a *perfect definition* of a visual *abreaction,* the term used in psychotherapy for a release of repressed or forgotten emotion. In his 1986 lecture, Shadbolt commented of such fears and passions that the artist puts *a net of designs over them, across them: once you've got it under control, you've gotten power over the object instead of it having power over you. That was Picasso's real discovery. Not making pictures, but gaining power, personal power over experience.*

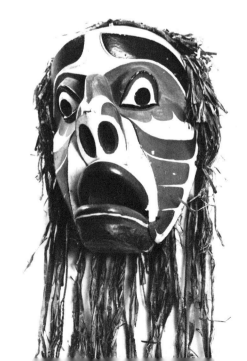

In **Red Knight**, painted in the same year as the **Killer Birds,** Shadbolt adapted his realistic 1938 sketch of a Numahl mask, gave it an entirely new context, that of medieval armour, and *created a viable human image with which to make some comments of [his] own*. The armour is an inside/outside image, of course, as well as another kind of mask and another image of death. This painting marks the emergence of another of Shadbolt's lifelong fascinations, setting aspects of organic and mechanical form in juxtaposition.

Figures 14, 15, 16. In the **Killer Birds** series, Shadbolt put the Indian masks he saw in one part of the old B.C. Provincial Museum on the bird skeletons he found in another. A Museum of Anthropology Southern Kwagiutl monster bird mask from the Hamatsa dance series is shown next to the painting.

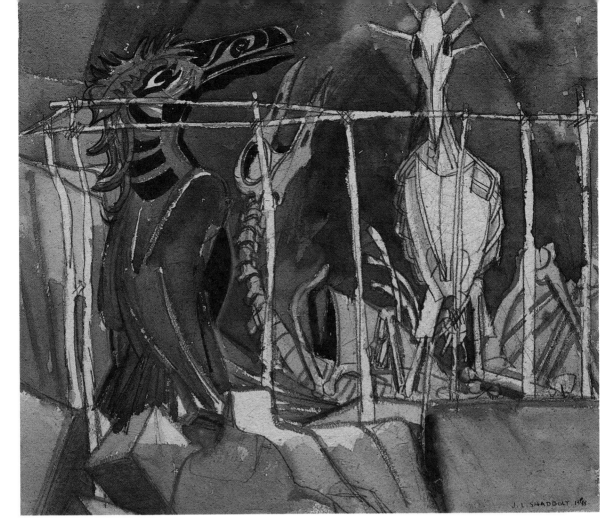

Figure 16.　**Sea Caves** (**Killer Birds** Series).

Figures 17, 18. A 1938 sketch of a Numahl mask is recontextualized as European armour, a typical Shadbolt combination of images, in **Red Knight,** 1948. Sketch not exhibited; photographs courtesy Jack Shadbolt.

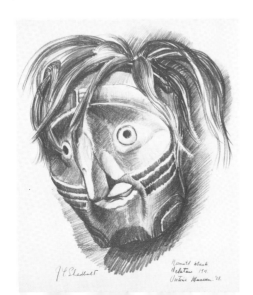

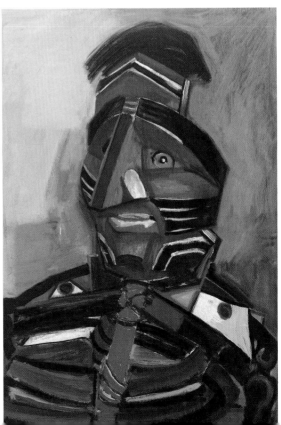

Later that year, Shadbolt returned to New York and attended the Art Students' League for a while. **Coast Indian Theme**, painted in 1952 (figure 19), demonstrates new ways of handling pictorial space, of relating elements in the painting to each other, that were absorbed on that 1948 trip. *Miró gave me the clues I was looking for, too*, he told students in 1986, *because as long as the objects were rooted on the bottom margin of the picture, and fell backwards into the picture space, then I was still in the old Renaissance pictorial form. I noticed in Miro that the objects simply float free across the panel. They had no determinate space whatsoever, no foreground, no background.* He cut his forms loose, as in **Coast Indian Theme**, and *began to get a whole new grasp on a floating world.*

Jack Shadbolt was able to *cut the umbilical cord to nature* and release himself from documentary and perceptual art only after he had seen death and destruction abroad and returned to British Columbia with strong, negative emotions which he *needed* to express in visual form. At the same time that he discovered that animal skeletons could be expressively rearticulated on formal rather than realistic anatomical principles, he was jolted emotionally by the force of Coastal Indian artifacts. Not surprisingly, he was drawn to those used by the Southern Kwagiutl in their Hamatsa or Cannibal Dance series, in which a dancer who has been possessed by the spirit of a maneating monster is ritually tamed or exorcised.

Shadbolt himself believes[17] that the *lessons* of Indian art that helped him toward his *own personal mode of abstraction* were its 1) *sectional stylization*, 2) *fusion of the actual and mythological image*, and 3) *fusion of inside and outside concepts.* He also refers to the x-ray *eye* and *sectional view* (see his own statement, p. 26).

I see this somewhat differently. Over the years, in his own writings and interviews with others, Shadbolt has invoked variously Picasso, Miró, skeletal power, Indian art, and bombed buildings as providing seminal insights into the nature of abstraction. In each instance, he is referring to a comparable process, one in which an articulated form is dismembered and its parts rearranged according to a new principle of the formal relation between these parts.

Although a similar principle can be observed in Northwest Coast formline painting, Shadbolt does not refer to it: his artistic relationship is with Indian sculpture, not painting. Since sculpture, especially masks, is expressive in a way that Indian painting is not, the affinity was predictable. For Shadbolt, the critical connection occurred in 1947, when he brought abstracted skeletons and Indian masks together and created both formal and expressive coherence between them. The pivotal image seems to have been **Image with Red Bones,** soon followed by **Red Knight** and the **Killer Birds** series, all of which contained the same conjunction of skeleton and mask, inside and outside. The fact that he discovered the freedom of abstraction before he went to New York in 1948, and that this discovery occurred out of deep personal necessity, means that we see an authentic postwar primitivist response to the brutality of Nazism.

According to the art historian Kurt Varnedoe, *The primitivism of the early New York School, in its urge to create a mythic form of expression appropriate to the time, should be seen as engaged in a program of abandoning materialism in order to take into account the challenge of the Nazis...* [18] Not only did Shadbolt anticipate this response, but he would later parallel the New York artists in significant ways in developing his own spontaneous way of painting, which he calls the *act of art.**

Figure 19. **Coast Indian Theme**, 1952. *In disposing these figures within the total pictorial concept... I arranged their movements to one another by a firm assertion of their shapes and space interval interactions. By this means, which had now become habitual with me, I had learned to preserve the continuous surface tension of the whole picture plane, yet also to maintain the conceptual view of unit parts* (Shadbolt 1968: 192). Photograph courtesy Jack Shadbolt.

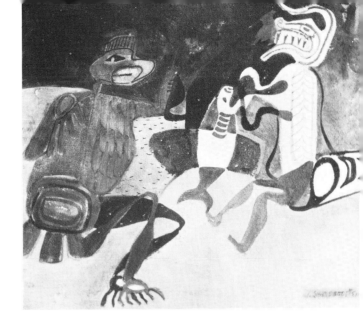

Figure 20. **Variations on a Coast Indian Theme**, an abstract painting from the 1950s, consolidates the artist's grasp on the new "floating world" of the picture space.

Figure 21. **Risen Sun**, 1964. This little painting anticipates the relationships between underground and rising suns that will surface so prominently in the paintings of 1985-86. In 1986, Shadbolt produced a limited-edition silkscreen print, entitled **Risen Sun**, that was based on this painting (see figure 52, p. 48).

*There was another artistic movement in the New York of the 1940s called "Semeiology" or "Indian Space," whose members were influenced by Northwest Coast Indian two-dimensional painting, from which they took the challenge of creating *all positive space*.[19] Shadbolt was not aware of their work.

 1. Ian Thom 1980:7.
 2. Jack Shadbolt 1968:64.
 3. quoted in Doris Shadbolt 1979:30.
 4. D. Shadbolt 1979:34.
 5. D. Shadbolt 1979:53.
 6. D. Shadbolt 1979:53.
 7. D. Shadbolt 1979:62.
 8. Hawthorn, Belshaw, and Jamison 1958:12.
 9. quoted in Thom 1980:8.
10. J. Shadbolt 1968:35.
11. quoted in Thom 1980:9.
12. J. Shadbolt 1968:35.
13. quoted in Thom 1980:9.
14. William Rubin 1984:254.
15. Rubin 1984:255.
16. Malraux, quoted in Rubin 1984:255.
17. J. Shadbolt 1968:44.
18. Kurt Varnedoe 1984:652.
19. Ann Gibson 1983.

Figure 22.

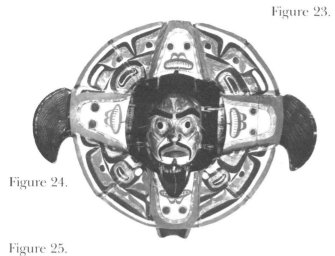

Figure 23.

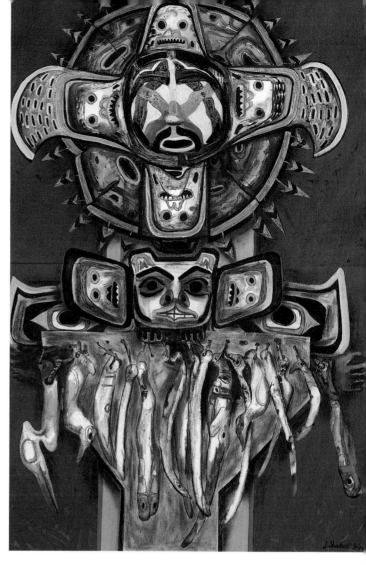

Figure 24.

Figure 25.

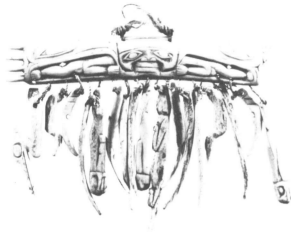

Figure 26.

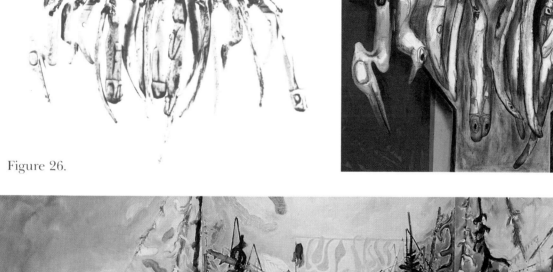

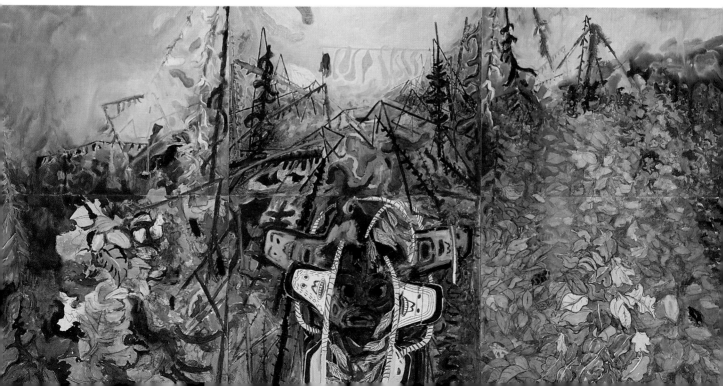

From Primitivism to Place

Jack Shadbolt continued to use Coast Indian motifs in minor ways for the next twenty years. Then, a 1969 retrospective, organized and circulated by the Vancouver Art Gallery, *sort of cleaned me out and I was starting again*.[1] He started again by returning to Coast Indian sources.

While there had been isolated signs of a new cultural quickening in Indian society during the two previous decades, it was not until the year of Shadbolt's retrospective that a real turning-point could be recognized. In response to a 1969 federal white paper containing policy proposals for the "final assimilation" of Canada's Indians, two new provincial organizations were formed, the Union of B.C. Indian Chiefs and the British Columbia Association of Non-Status Indians.[2] Also in 1969, the Haida artist Robert Davidson raised the first totem pole on the Queen Charlotte Islands in nearly a century, and an elaborate potlatch was held in memory of the Southern Kwagiutl artist and chief Mungo Martin in the new Big House at Alert Bay. As well, the Native population had risen from a low of 22,600 registered Indians in 1929 to some 40,800 in 1963 and was expanding steadily.

Shadbolt's return to Coast Indian sources was still in the syncretistic mode of international primitivism, however, and in several major paintings of the early 1970s he simply generalized and extended Coast Indian forms to include other tribal art, principally from the southwestern United States and Melanesia. While a practised eye can recover the original cultures, and sometimes an original artifact, for the most part these paintings are "generalized primitives": motifs are used in non-specific ways, and elements from more than one source are often combined in the same work. Shadbolt himself comes into focus in these paintings, which are large, colourful, figurative, and passionately painted, but their cross-cultural specificities are lost.

To pursue such specificities, to try to recover the originals that inspired these paintings, is to misread primitivism as a genre. Primitivism is not "about" primitives; it is about painting itself.

The New York primitivists of the 1940s, including Barnett Newman, Mark Rothko, Adolph Gottlieb, and Jackson Pollock, had celebrated tribal art as *an assertion of anti-racist cultural relativism* and a universal *precondition of individuality*.[3] Tribal arts acquired *the special prestige of the timeless and instinctive, on the level of spontaneous animal activity, self-contained, unreflective, private, without dates and signatures, without origins or consequences except in the emotions*.[4]

Figure 22. (preceding page) **Guardian Spirit of Owl**, 1971. A good example of symbolic ambiguity. A mask seems to wear a living owl headdress that seems in turn to be worn by another owl. The coastal Indian references are incidental.

Figures 23, 24, 25. (preceding page) **Guardian**, 1971-72. This painting is based on a National Museum of Man Bella Bella transformation mask, a set of Tsimshian charms in the Smithsonian Institution, and a beaver bowl transformed into a mask. Photograph of Tsimshian charms courtesy the Smithsonian Institution, Photo No. 71-71-30.

Figure 26. (preceding page) **The Place,** 1972, shows the same Bella Bella transformation mask disintegrating into the bush, with suggestions of salmon drying in the background.

This process was accompanied by indifference, not only to *just those material conditions which were brutally destroying the primitive peoples or converting them to submissive cultureless slaves,*[5] but also to the forms and craftsmanship of the actual tribal arts used as sources. *The spirit of the new primitivism was one of synthesis, and it sought out elemental forms of quasi-autonomous archetypal universality—banishing in the process the culture-specific inflections that had often accompanied earlier primitivizing art .*[6]

The contradiction between primitivism and tribal reality was resolved in the emergence of Abstract Expressionism at the end of the 1940s, as the New York primitivist movement shifted to a *mature expression in types of abstraction that show no evident links to tribal styles.* In other words, primitivism was now about the act of painting, as it always had been, even when it appeared to be about tribal art.

Guardian Spirit of Owl, 1972 (figure 22), is the least culturally specific of the paintings considered here—others of Shadbolt's "generalized primitives" are illustrated in Tamlin, 1984. The painted face may or may not be a Northwest Coast design: the human is wearing a living owl headdress, or is another headdress wearing a man? The title refers to the mystical relationship of a shaman or initiate and his or her guardian spirit, or helper. There is no correct way to read such images, images that hint of being symbols of something yet remain ambiguous even to the artist himself. Primitivist paintings exploit symbolic ambiguity to reveal a universal, creative human spirit. Indeed, Shadbolt consciously avoids the explicit image in order to create a *poetic enigma of content* (journal entry, p. 26). Part of the potency of all primitivist painting is that the viewer can make a connection between ambiguous yet obviously symbolic imagery and whatever personal understanding of tribal symbolism he or she has acquired. Nor does the artist need complex ethnographic knowledge to release it in others. It is the very ambiguity of the image that sets the viewer's meaning-seeking mind moving towards its own interpretation of that image.

In **Guardian**, 1971-72 (figure 25), a Bella Bella transformation mask, a group of Tsimshian shaman's charms, and a beaver bowl emerge with some clarity as artifacts, although the human face inside the eagle mask has been generalized and simplified. **The Place**, 1971-72 (figure 26), shows the same Bella Bella eagle/human mask disintegrating into what looks like wilderness bush but is in fact Shadbolt's garden. Salmon may be drying on a rack in the distance. In a 1981 lecture at the Art Gallery of Ontario, Shadbolt described the central figure as a *lost person locating himself in a place, like a novice sent out into the forest to communicate with the spirits* [and] *purify himself through nature.*[7] The mask, and the artist, are now located specifically in British Columbia. This painting is not in the culturally casual mode of international primitivism: it is the lyrical evocation of a definite place. There is a suggestion of time in the work as well, with the disintegrating mask invoking a historical process rather than the timeless mythological presence of the international primitivist. **The Place** holds in balance the two tendencies that will mark Shadbolt's Indian paintings for the next fifteen years—the opposing pulls between home and internationalism, Indian art and the organic delights of nature on the one hand, and the universalizing artistic language of Abstract Expressionism on the other.

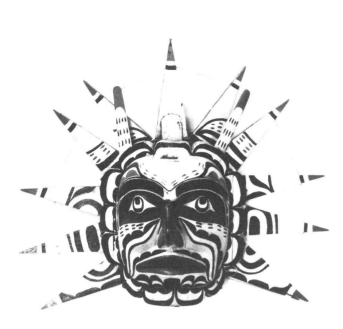

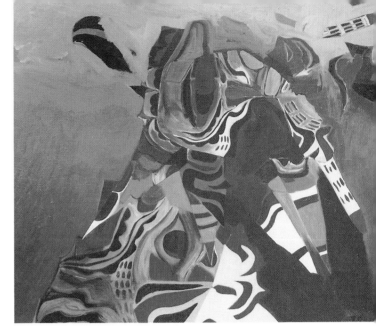

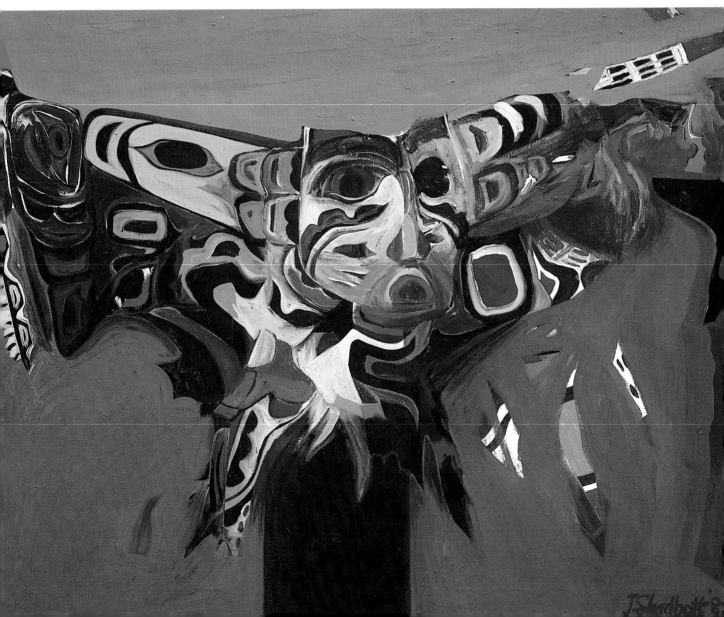

Figures 27, 28, 29. The disappearance and reappearance of a Southern Kwagiutl Sun Mask in **Coast Memory IV** seems to illustrate Picasso's statement about abstraction: *One always has to begin with something. One can then remove all appearance of reality; one runs no risk, for the idea of the object has left an ineffaceable imprint. It is this that aroused the artist, stimulated his ideas, stirred his emotions. Ideas and emotions will ultimately be prisoners of his work; whatever they do, they can't escape from the picture; they form an integral part of it, even when their presence is no longer discernible* (quoted in Ghiselin 1952: 57). The first version was painted in 1982 and the second in 1986. The Museum of Anthropology's Southern Kwagiutl Sun Mask can barely be recognized in the two striped sun's rays that project out into the right side of the painting, which is seen to be more fragmented than the left.

Figures 30, 31. **Variation on a Kwakiutl Ghost Mask,** continues the energy of the 20-panel suite that preceded it in 1976. Photograph of the Hamatsa Ghost Mask courtesy the Milwaukee Public Museum, No. A22C.

In 1975, Jack and Doris Shadbolt travelled in India, Nepal, and Afghanistan. On their return, he created a monumental twenty-panel **India Suite** and continued the swinging improvisational rhythm of that work in another twenty-panel series featuring Coast Indian masks and other artifacts (figure 54, page 58). In **Jack Shadbolt and the Coastal Indian Image,** Museum of Anthropology exhibition designer Herb Watson, assisted by student intern Beth Carter, arranged the sixty-eight-foot length of this latter work to form a room surrounding visitors, bringing us literally inside the painting, where four of the actual masks imaged in it were displayed.

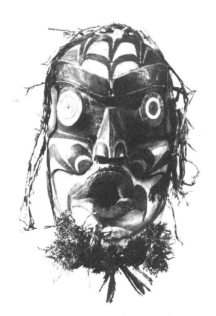

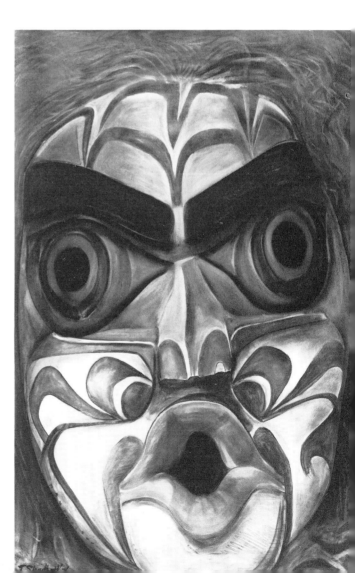

In 1976, Shadbolt described the *additive process* painting of the first of these monumental suites in a way that also describes the creation of the second: *Once I had started improvising from Indian sculptural forms I began to take off on an extended trip of my own. As the rhythm swung from drawing to drawing so also the interaction between images began to pile up.... Panel after panel took shape as new images suggested themselves by the sheer form necessities of linkages. I would place a blank panel between two unrelated ones and improvise a new image to connect the other two formally, pulling in the links from each side.*[8]

The organic, dynamic relation of artifacts and forest in **Coast Indian Suite** reveals, even more than in **The Place**, that Shadbolt, like Carr, believed that, in Scott Watson's words, *the highly sophisticated arts of the Northwest Coast have an organic relationship to the world. This relationship is something that both artists constantly struggle to recapture for the tradition of modern art.*[9] The Indian presence, according to Shadbolt (journal entry, p. 26) gives *my view of nature a deeper solemnity, a nostalgia for oneness with a wild world.*

It is necessary, however, to make an additional distinction, one that romantics consistently overlook: the forms of Indian art are sharp, crisp, and in essence related intellectually to the forms of nature. Coastal Indian art is profoundly assertive of artifice, of culture, and not of nature. It is abstract, not organic. Only in the European imagination do Indians exist as Natural Man. According to their own sense of themselves, they are profoundly civilized. Those who project romantic values—spontaneity, freedom, simplicity—cannot help distorting the complex, conservative, and hierarchical nature of Coastal Indian society.

Worringer makes this distinction in the 1908 classic, **Abstraction and Empathy**. Wentinck summarizes his argument as follows: *The wish to identify oneself with the world—which is the point of departure for every artistic experience—is satisfied by the beauty of organic life. The need for abstraction, on the other hand, seeks gratification in the beauty of all that which denies this organic existence, in the crystalline world, quite simply in the world of laws and necessity.*[10] Indeed, these are the two opposites—the organic and the abstract—that Jack Shadbolt is ever seeking to reconcile.

Worringer and Wentinck, quite correctly I believe, see the "need" for abstraction as *the result of a profound inner disquiet in man when faced with the world; it corresponds, in a religious sphere, to a transcendental conception of the universe.*[11] The less we humans understand of the processes of the world, the *stronger is the impulse* to *create a powerful and abstract beauty.* This notion is also at the core of Wilson Duff's 1975 essay, **Images Stone BC**, as yet unappreciated by other scholars, in which he argues that the Indian artists of the Northwest Coast were *thinkers* and *mathematicians.*

The year after **Coast Indian Suite** was painted, 1977, is seen as another turning-point in British Columbian Indian affairs, one identified by UBC political scientist Paul Tennant as the emergence of *tribalism.*[12] As the new province-wide organizations of 1969, funded by government and structured on governmental administrative models, began to founder, a new generation of political leaders educated in the 1960s were returning to their home areas. They created a political reality based on an ideal of the unity of status and non-status Indians and on the tribal group, rather than the district, as the basic political unit. Still, the *unchanging feature of Indian political activity since 1969, and before, has been pursuit of the aboriginal land claim as the paramount goal.*[13]

The year 1977 also marked the founding of the Northwest Coast Indian Artist's Guild, a group of eleven contemporary Native artists committed to bring *the general public to recognize quality art of the Northwest Coast Indian people, and assure them of its authentic Native origin.*[14] By this time, the registered Indian population of the province was 54,000.

Is it too simplistic to read the new integrity of the Indian artifacts in Shadbolt's **Coast Indian Suite** as reflecting this new Indian political and cultural reality? Perhaps: but I invite the reader to suspend judgement on the matter until we see what happens in the 1980s.

1. quoted in Illi-Maria Tamlin 1984.
2. Paul Tennant 1983:114.
3. Kurt Varnedoe 1984:652.
4. Meyer Schapiro 1978:201.
5. loc. cit.
6. Varnedoe 1984:627.
7. quoted in Tamlin 1984.
8. quoted in Scott Watson 1985:11.
9. Watson 1985:11.
10. Charles Wentinck 1978:12-13.
11. loc. cit.
12. Tennant 1983:136.
13. loc. cit.
14. Roy Vickers 1977.

Entry from Jack Shadbolt's journal, 24 February 1985

Now that preparations have begun for the exhibition of my Coast Indian-influenced work, it is perhaps time I tried to define for myself just what my relation to this native art has been.

First off—and this is easiest to say in a broad generalization—the Coast Indian is the nearest symbolic mythology to hand. Originally fired, I suppose, in my formative early years, by contact with Emily Carr, my interest was fanned by her powerful and brooding evocations of tragedy in the dying culture of the abandoned Indian villages with the romantic grandeur of their remnants standing against the overwhelming wilderness, an image that appealed to my youthful temperament.

But I think I also had an instinctive yearning for the theatrical drama of the story-teller—a legacy, as I now see, which came from my mother who was a perpetual dreamer of grand dreams (albeit cast in the mode of bourgeois romance). At any rate, early on, I took to loving the notion of the theatre and being an actor was one of my high-school joys which led me later to the Little Theatre movement and stage designing. So when I started to draw seriously my focal interests were the suburban landscape and the Coast Indian masks in the Victoria museum. My first teaching job was at Duncan where I lived next to the Somenos [Cowichan] Indian reserve which I drew frequently. Thus grew my interest in Indian things; and from then on masks had a special significance for me as a way to get at human states without resort to traditional portraiture.

Later, after serving my apprenticeship as a landscape-oriented artist, I was led by historical inevitability toward abstraction. Mere stylization did not seem expressive enough though it strengthened my decorative sense. But I needed more—a more psychologically involved form-relationship process. I turned toward primitive art, especially the fertile areas of African and Oceanian. Picasso,

who dismembered and reassembled the elements of the figure for greater psychological expressiveness, seemed the right intermediary for me. I had already encountered the notion of the cross-sectional image from anatomical diagrams, from Australian Bushman art, and certain flattened out medieval emblems so when I returned home again, after museum travel study, to the Coast Indian images of killer whale, dogfish and the rest where both the outside shape and the inside content are shown simultaneously in a sectional image, I knew I had my final clue to releasing my drawing, through design, from European bondage to the external view. The Indian mode of expressing things from inside out, out of deep interior identification with the spirit of the image portrayed, gave me my inventive impetus as well as helping me to my personal mode of abstraction.

As I further explored the notion of fetish my improvisational expressiveness increased. When still later I became interested in the triptych form and its consequent formalizing of the iconic format, I was led into the territory of ritual, in the functions of which I began to develop a lively interest. The ritual's capacity to handle deep, traumatic experience, by acting it out by surrogate through richly ornamental symbolic drama, brought out all my accumulated theatrical urges. It also offered a way of dealing with suggested symbolic overtones without being too explicit, thus preserving a poetic enigma of content which I craved. I found much of this quality in the Coast Indian legends.

Lastly, the concept of the Shaman appealed to my dramatic and inventive leaning and gave me the final encouragement to free-wheel my abstract tendencies into a language of form imagery free from conventional restraint or responsibility to external nature. I began to realize myself as part of nature, a creator of magic by the process of juggling forms which come alive and mysterious as they interact their creative necessities into unpredictable meanings.

In and out of my many years of off-and-on contact with Coast Indian art, I found myself in complete sympathy with the Kwagiutl psychologically transformational decorative inventiveness on the one hand and with the moody monumentality of the Haida sculpture on the other and, in addition, something of the demonic ferocity of the occasional Tlingit mask. They have left me with a permanent emotional overtone of our coast landscape to be explored. Their imprint is on my mind. Whenever I look out on our wilderness I am haunted by evocations of their memory. They endow our world with the nearest tangible traces of a fading culture; and thus they give my view of nature a deeper solemnity, a nostalgia for the oneness with a wild world—and a reproach to aspects of our pragmatic environment.

Yet the most permanent residue of all, for me, has been the vestiges of predilection for certain aspects of form that have a distinct Coast Indian reminiscence and the intrusion into my colour vocabulary of the handsomeness of the red, green, black, white elements that characterize so much of the Indian design tradition. And, too, the yellow, black, white combination which I love stems, it is possible, from the Chilkat blanket. And there are aspects of flat space coming from the opened-out emblematic design process of the Coast Indian decorative tradition that helped me to wean myself away from the old-depth painting idiom toward a confident negative-positive deployment of the picture plane itself.

All in all, it is a complex, on-going relationship which has developed between us for which I acknowledge my debt with gratitude.

Figure 32. Museum of Anthropology painted box. A Northwest Coast abstraction.

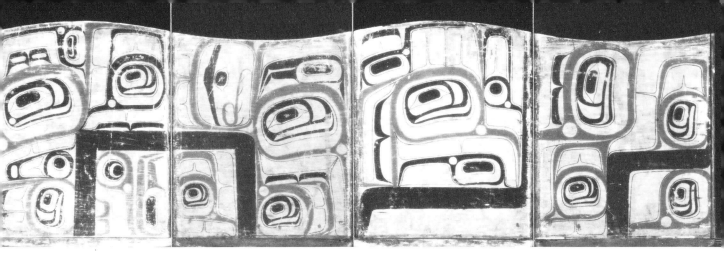

"Act of Art"

If an older taste said, how exactly like the object, how beautiful!—the modern abstractionist says, how exactly like the object, how ugly! The thoroughly abstract painter thus *denounces representation of the outer world as a mechanical process of the eye and the hand in which the artist's feelings and imagination have little part.*[1] My purpose in this section is to describe Shadbolt's way of painting in order to arrive at an understanding of how he can say, with Jackson Pollock and other modern artists, when dismissing the issue of painting from nature: *I am Nature.*[2]

Shadbolt and his wife Doris, herself an art critic and historian, curator, and cultural broker for Northwest Coast and Inuit art, spend their winters on Capitol Hill in suburban Burnaby and summers at a Hornby Island cottage. During the time we were planning this show, Doris was writing a book about Bill Reid, the Haida artist whose exhibition, **Bill Reid: Beyond the Essential Form,** coincided with Shadbolt's at the Museum of Anthropology. Their Burnaby home reflects a shared love of museums. He writes: *I had been an inveterate haunter of museums in my student days and have retained a continuing passion for the richness of textiles, ceramics, armour, costumes and primitive artifacts, masks and fetish sculptures. In our house I am surrounded by such tokens from*

a mixture of cultures. This is where history gets to me—where I live.[3] On Hornby Island, the Shadbolts decorate their cottage with shells, dried flowers, and other natural materials.

Shadbolt has studios at both Burnaby and Hornby, where he paints large canvases or watercolour boards tacked up on a wall at the end of the studio that faces its entrance. While he works in various styles, he is always seeking the *hot* and *hopped-up* state which he calls the *free-wheeling stage* of *the most unusual transformations,* a condition he compares with *speaking in tongues* and *inspired chatter.*[4] In this state, he paints by *sloshing on the acrylic in viscous gobs and splashes* at a fast, assured, and rhythmic pace. The phrase, *speaking in tongues,* provides an interesting clue. For Christian ritualists, speaking in tongues means speech inspired by the Holy Ghost just as, in Native ritual, the song that bursts from the initiate is a gift of the spirit.

At other times, he labours diligently on an image, working and reworking its elements until he has won, by considerable effort, the fusion he aspires to achieve spontaneously. Two of the paintings in this book, **Coast Memory IV** (figures 28, 29) and **Toward Totem** (figures 34, 35), shown in two different stages of completion, reflect this process.

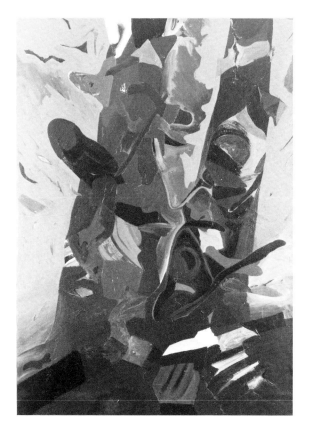

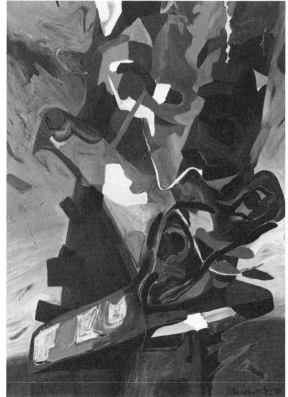

The first time I watched Shadbolt work was at a session during which he extended the imagery on one 3.5x5-foot watercolour board to three others, making a quartet. For me, *It was quite thrilling, and very high-energy. When he drew a first violet/lavender line on the virgin canvas, I physiologically shared the thrill. Jack worked rapidly, to the novice viewer it looked reckless, and the quartet was completed in an hour. To his great satisfaction. To my own delight, I had been able to catch his logic from time to time. To see that one form or area of the painting needed to be balanced—completed—by another, and to see that his choices were rapid and correct (according to that strange visual logic by which forms work). He said he was creating unities or "after unity."*

Shadbolt writes in this way of the process I observed: *The miracle of the creating of a work of art is that each particular move, working by relation to the last move, seems so inevitable that the creator can't think or care where it came from or if it is useful in the future, but only that it is right. Creating is not an exercise in aesthetics but an act of sensory discovery. Having made a right move, one parlays it to the next move, and the next, and the next, until the (visual) reality grows into a unexpected* **thing** *under one's hands.*[5] In other words, the work takes on the qualities of *a sensuous organism* that *must grow of its own nature so that both the form and the artist, in making it, are in a mutually unfolding discovery.*[6]

Elsewhere he writes, *I have very little of the mystic in me, but if there is any it is in my rapture when, in the work process, that state is attained where everything seems a part of everything, each form existing for itself but not being itself until it also answers every other form in a perfect coordination of reciprocal intent.... The "whole is greater than the sum of the parts" is what art is all about.*[7]

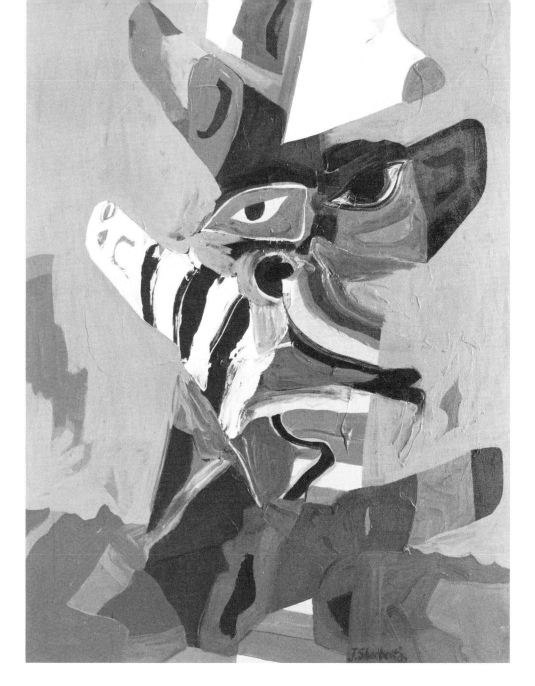

Figures 33, 34, 35. The Museum of Anthropology's **Toward Totem** in two versions, 1982 on the left (photograph courtesy the Bau-Xi Gallery, Toronto) and 1986 on the right. The earlier version shows a penis jutting off to the left: this is transformed into a raven's beak in the second painting. The equation beak = penis is one of the themes of Wilson Duff's **Images Stone BC**, although there is no evidence that Shadbolt was aware of this when he changed the painting. The sunlight shining on the beak suggests a regenerative principle at work, while the disintegration of the pole on the right sharpens the left/right relationship of the previous paintings and brings it into sharper focus as a falling away of the same thing, in this case a totem pole, that is being regenerated. The Art Gallery of Greater Victoria's **Into Totem,** 1982, is also shown. Photograph courtesy the Art Gallery of Greater Victoria.

He always knows why he *put that line there* but, and this cannot be overemphasized, he usually does not know where the painting itself is going. The *act of art* has taken over and must play itself out. He is lost in *the spell of a work as it develops. For me, I can only say that I go inside* the experience and let it possess me by its process of free association and improvisation, trusting to my artistic control to fuse and stabilize it. It always surprises me to see where the work finally comes out after knowing where it went in ...[8]

One of the greatest delights of the artist, he believes (1981), *is to let his senses respond unresistingly to rhythmic proliferation. There is an intoxication about letting it swing...* He uses the analogy of a jazz musician who says, *Just whistle me a tune*, and then *takes off on magic fingers*.[9]

Improvisation touches a dream that lies deep within all of us—the desire to be free of all obligation, to be able to follow our mood or whim and to "play it by ear" without foreplanning or following a dictated course or being sensible or decorous. To be as free as the wind or as free as a bird in the sky are atavistic longings. In this realm of fancy one follows any daring lead the mind invokes; and here, in this world of artistic improvisation of images, one can be similarly free.

Scott Watson has identified this way of painting as distinctive of Vancouver in the late 1940s and 1950s and fundamentally similar to the New York School of Abstract Expressionism of that same era: *Both placed importance on the act of painting. The aim of this kind of painting was to produce the unconscious. The value or interest of a painting was as a record of the unconscious process which had produced it. When the painter "loses himself" in the act of painting he is producing knowledge of the unconscious.*[10]

Any description of Jack Shadbolt's way of painting or, indeed, any examination of the vibrant, passionate colours and forms in his paintings, achieves added dimension when the painter is contrasted with the man, the citizen. The wildness of the former disappears into the controlled, contained, and totally civilized persona of the citizen, a responsible member of the community, who gives no hint in his public self of the ecstatic, enraptured being who paints. To use the analogy of the transformation mask, it is the inner being who paints, not the outer persona. Like the song of the Indian artist, the work is a burst of inspired, unpremeditated manual singing.

Understandably, Shadbolt is fascinated by the ritual process, in which he sees the *capacity to formalize powerful human drives from the unconscious into ceremonies of revealed meaning.... Through the splendour of their elaborations, [rituals] allow us to look face-on into the unthinkable which we have hidden under layers of fear or superstition.*[11] Rituals, he writes, *unite us with our atavistic selves: You discover that there's another, more fundamental process—that of ritualizing your experience*, or *putting a pattern over the thing you want to bring under control.*

This idea of *putting a pattern* over the raw sensations of fear, awe, dread, and other negative emotions is certainly in tune with Shadbolt's subject matter—the ghosts, man-eaters, ogres, and other personifications of Northwest Coast ritual theatre. His insight that these represent forces and aspects of humanity which are thus brought under control is ethnographically correct. The dances of initiates all over the coast are variations on the theme of taming the wild and spirit-possessed initiate and restoring him or her to a human state.

Figure 36. **Pisces,** 1986, shows a soulful and
shattering mask with two salmon that emerge
and recede in the viewer's eye. There is the
same tendency as in **Coast Memory IV**
(figures 27-29) for the right side to disintegrate.
This painting suggests an image of the sun
mirrored in the sea.

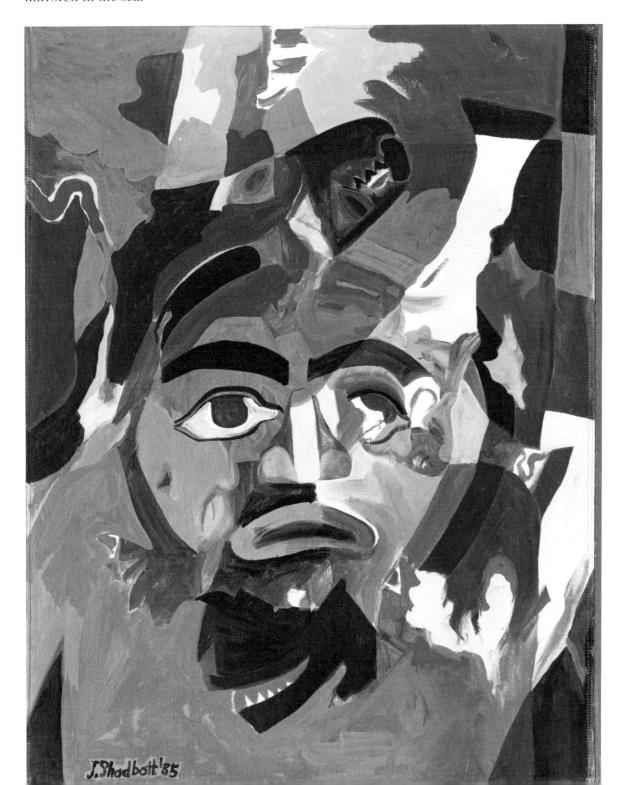

Figures 37, 38. **Drum Song,** 1986. This painting of a shaman's drum from the Provincial Museum is a good example of what Shadbolt calls the fusion of inside and outside views. The figure has stylized ribs and organs. Photograph of drum courtesy the British Columbia Provincial Museum.

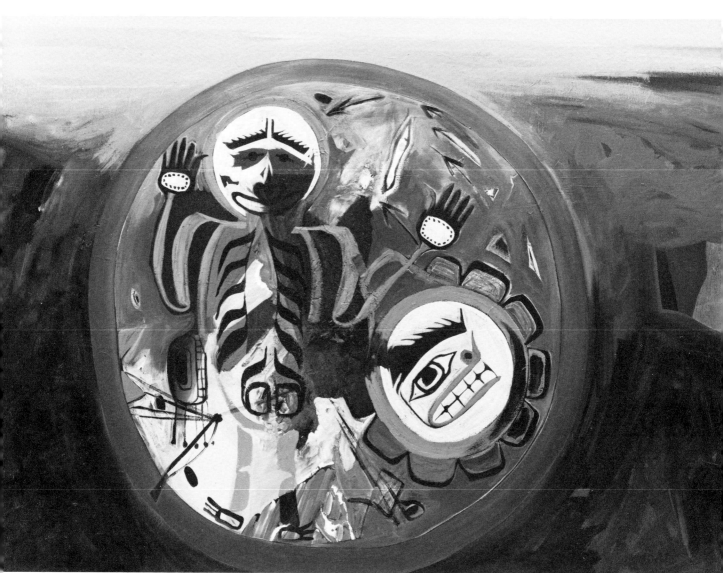

Both Jackson Pollock and Jack Shadbolt have been mythologized by critics as artist/shamans, a romantic attribution Shadbolt willingly accepts: *The concept of Shaman appealed to my dramatic and inventive learning and gave me the final encouragement to free-wheel my abstract tendencies into a language of form imagery free from conventional restraint or responsibility to external nature* (journal entry, p. 26). *It has indeed become customary to refer to Shadbolt as a shaman*, writes Vancouver critic Joan Lowndes: *He invents his own myths, communes with his own spirits, makes his own magic.**

The beginnings of a Shadbolt painting are always extremely inchoate. In the rapture of the creative process he allows his unconscious to flow onto the paper, all the while at another level remaining the highly accomplished artist, ready to use his wits to ensure the right passages of colour and birth of form. It is important to realize how improvisational, almost automatic, Shadbolt's own work method is in order to appreciate the strange graftings of motifs which occur under his brush.[12]

Pollock also worked in an automatic, entranced way. His own observations are much like Shadbolt's: *When I am in my paintings I'm not aware of what I'm doing. It is only after a sort of "get-acquainted" period that I see what I have been about. I have no fears about making changes, destroying the image and so forth, because the painting has a life of its own. I try to let it come through. It is only when I lose contact with the painting that the result is a mess. Otherwise there is pure harmony, an easy give and take, the painting comes out well.*[13]

*See Woodcock, 1973-74; Lindberg, 1978; Tamlin, 1984.

For Pollock, as for Shadbolt in his internationalist mode, painting is an assertion of individuality. *This individual is without a history, that is to say without a strong cultural context to bind him. There is a mythic context that constantly invites him to freedom, if he can only "kick over the traces," to get beyond convention and make of himself what he can, to establish his own territory and his own reality...*[14]

This notion of the shaman as a tribal individualist has also been argued by UBC anthropologist K.O.L. Burridge in his book, **Someone, No One: An Essay on Individuality** (1979). Burridge draws a distinction between a someone who conforms to social roles and norms and a no one whose nonconformist perceptions result in independent moral discrimination and innovation. He views the shaman as achieving individuality through a initiatory process of symbolic death and dismemberment—which he calls the *vocational trauma*—followed by renewal and resurrection as a new self emerges. There are hints of a similar transformation in the emergence of new artistic styles in the work of both Picasso and Shadbolt as they responded to death with the borrowed idiom of tribal sculpture. Like the modern would-be shaman/artist, the tribal shaman is an ecstatic. *Yet since it is required that the ecstasy be controlled ... cultural and moral capacities must also be employed. Allowing, then, that the ecstasy is of itself some kind of spiritual experience, it combines the realization of cultural and moral potential with entry into... being.... The shaman has to experience—and in the vocational trauma indeed actually experienced— what others are experiencing or have experienced and become as everyone, knowing the the possibilities of being in all.*[15] No longer bound to the usual extent by ordinary conventions, the shaman is, in Burridge's view, the first human cultural type to achieve individuality in the sense of *being a whole human being.*

Although they are practised in an individualizing tradition, I also find it useful to think of both Pollock's and Shadbolt's spontaneous brushstrokes (or drips) as ritual gestures that conform to Claude Lévi-Strauss's model of ritual action. The French anthropologist considers ritual as a collective device to re-establish contact with the continuity of lived experience. His premise is that ritual's purpose is to break the hold of conceptual thought on experience, allowing humans to return to the *continuous* or seamless experience of reality.[16]

A bridge between collective ritual action, especially as formulated by Lévi-Strauss,[17] and expressionist painting is suggested by Denis Donoghue's observation: *That's why the abstract expressionist painter paints before he reflects, because reflection entails recourse to everything he wants to evade, to punish, or to subdue; ideas, objects, the whole apparatus of the given world.*[18] That world, writes Shadbolt, has already programmed him: *He is an intricate computer set to make meaning with form whose operation is programmed by his feeling, sensory awareness, tradition, habit, training and ideas, and it is triggered by some instant perception of a form relationship. Life is the ultimate programmer.... My paintings seem to me to be imprints of this inchoate flow passing through me into configuration. I seem to be observing their precipitation of time-memories almost more than I am imposing myself on them. I say to myself, "I'll make them behave," but in truth they make me behave.*[19]

The artist's job, and this is the origin of both his style and his authenticity, is to express, rather than manipulate, life's programming: *I like to leave the whole situation free-wheeling as long as it comes out of the act of painting and not out of cerebral dictation.*[20] Indeed, Shadbolt writes that the creative process slows down when he begins to *contrive with my mind*, to *think up themes.... I do my damnedest to keep* **out** *of my paintings.*

Shadbolt's notion that he is expressing life's programming is of more interest to me as an anthropologist than the more widely held belief that expressionist painters give form to a collective unconscious. People who live together in a community do not need to postulate universal archetypes or a collective human unconscious in order to understand their ability to respond to the work of an artist in their midst—they share with the artist things that are far more tangible, a place and a way of responding to it. *Art and the equipment to grasp it*, writes Geertz, *are made in the same shop.*[21] In the course of daily life, artists cultivate the ability to be open to the world, both to absorb it and to let it to flow through their shaping hands and consciousness into form.

Some such process is necessary to the interpretation I develop in the next section, that Shadbolt's relations with the Indian artifacts in his paintings are a reflection of the relations between Indians and non-Indians in British Columbia. Shadbolt himself anticipates this interpretation when he writes that *forms in relation to space equals man in relation to society.*[22]

1. Meyer Schapiro 1978:196.
2. Kurt Varnedoe 1984:629; Jack Shadbolt 1968:235.
3. J. Shadbolt 1975:31-32.
4. J. Shadbolt 1981.
5. J. Shadbolt 1968:preface.
6. J. Shadbolt 1968:220
7. J. Shadbolt 1968:219, 235.
8. J. Shadbolt 1975:30.
9. J. Shadbolt 1981.
10. Scott Watson 1984:97.
11. J. Shadbolt 1985:30.
12. Joan Lowndes 1981:17.
13. quoted in Bernice Rose 1980:23.
14. Rose 1980:24.
15. Kenelm Burridge 1979:118, 119.
16. Claude Lévi-Strauss 1981:675.
17. see also Frits Staal 1979.
18. Denis Donoghue 1983:103.
19. J. Shadbolt 1968:preface; 1975:30.
20. J. Shadbolt 1975:20.
21. Clifford Geertz 1983:118.
22. quoted in Watson 1985:11.

Figures 39, 40. In Shadbolt's 1985 painting, **Bird Spirit**, the original mask's large raven headdress transforms into a smaller, cormorant-like bird. The expression of the mask is faithfully retained. Once again, the right side of the mask is disintegrating. The mask is below the horizon line. Photograph courtesy the Portland Art Museum, Kwagiutl mask, No. 48-3-408.

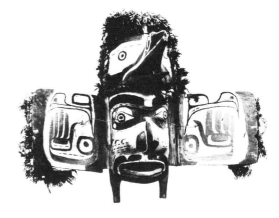

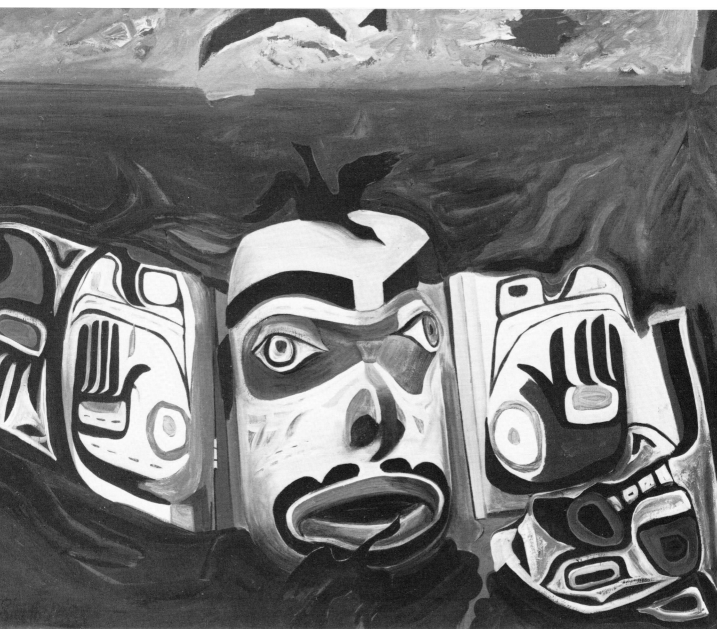

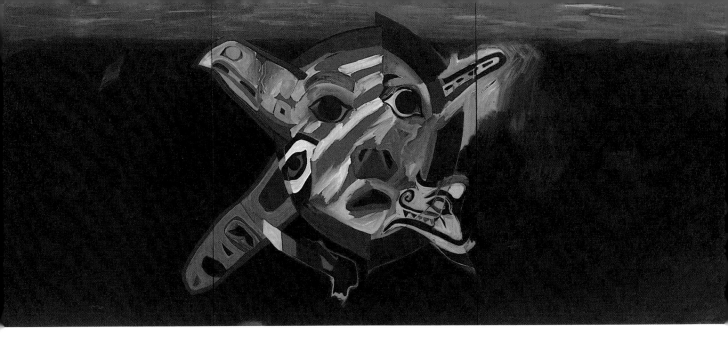

Figure 41.

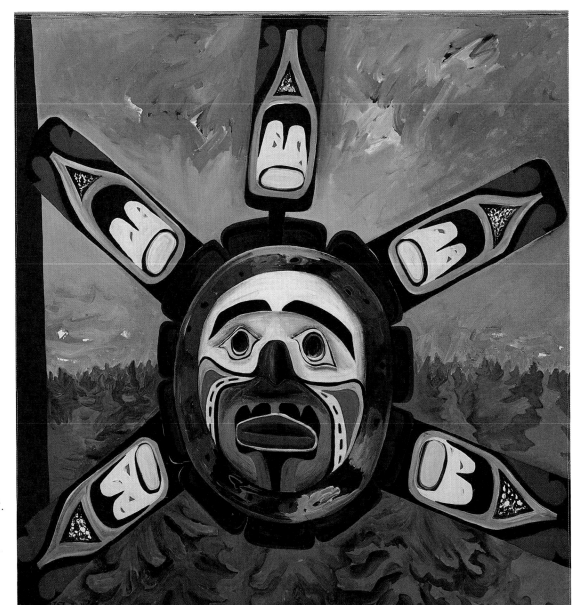

Figure 42.

36

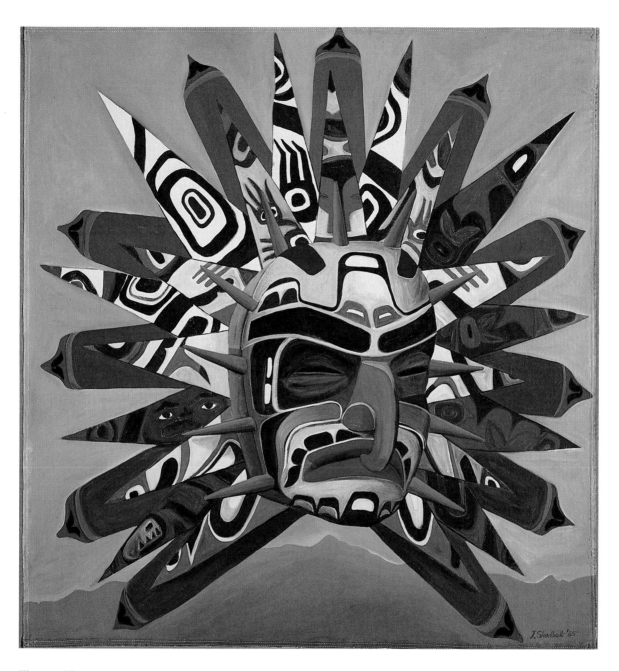

Figure 43.

Figure 41 (preceding page). **Silent Land**, 1985.
In **Silent Land**, a 1985 triptych, an under-
ground sun begins to rise. One of the rays on
the left is a raven's beak. The relationship
between wholeness on the left and disintegra-
tion on the right is still present. Photograph
courtesy the Vancouver Art Gallery.

Figure 45.

Figure 44.

Figures 42, (preceding page) 44, 45. **The
Valley Beyond**, 1985. The mask in **The
Valley Beyond,** an amalgamation of two Muse-
um of Anthropology masks, interposes itself
between the viewer and a healthy forest with
an imploring gaze. The right side of the
painting is no longer disintegrating: wholeness
has been achieved.

Figures 43, (preceding page) 46. **Grieving
Spirit**, 1985, and a B.C. Provincial Museum
Southern Kwagiutl Sun Mask. The mask in
the painting has now ascended high above the
mountains and moved fully into present
time. Photograph courtesy the British Columbia
Provincial Museum.

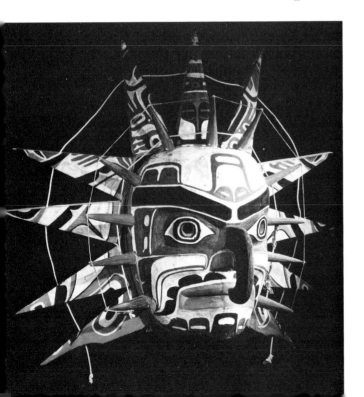

Figure 46.

Cultural Transformations

The answer to rootlessness, according to Margaret Atwood, *lies in acceptance of the land, which is done at least partly through legends, stories and words, through which we may discover,* in the words of John Newlove's poem "The Pride," *the knowledge of our origins, and where we are in truth, whose land this is and is to be.* The main emphasis in the poem, as Atwood reads it, *is on acceptance of one's place, and rebirth through that acceptance.*[1]

In Jack Shadbolt's 1985-86 paintings, we see more of the movement out of the timeless mythological realm of international primitivism and into the present time and specific place of British Columbia as foreshadowed in **The Place** of 1972. Not only are the recent masks rising from a dark, underground location, but their forms have achieved a new clarity, a quality that is almost super-real.

Comparing **Grieving Spirit** (figure 43) with the original mask brings into focus a persistent cultural pattern. While Shadbolt has transcribed the forms of the mask with care, including the painted designs on the face and the sun's rays, though adding some rays of his own, he has also narrowed the eyes to a squinting and sorrowful gaze, an amendment that both adds personality and emotion to the mask in the painting and points up their absence in the original. He writes (journal entry, p. 25) that he uses masks as a way to *get at human states without resort to traditional portraiture,* and we can see this in his mask paintings as far back as 1947, in Emily Carr's Indian paintings, and even in the little humans of **The Raven and the First Men**, Bill Reid's great sculpture in the Museum of Anthropology. Adding emotion to Indian sculpture, which is essentially emotionless, is a persistent attitude of Westerners that is also reflected in the anthropological literature, especially in the identification of northern human face masks as "portraits."[2] While a few nineteenth-century northern Northwest Coast masks in museum collections obviously do represent individuals, these appear not to have been worn, but made for sale to tourists. The human faces in Indian art, on totem poles, masks, rattles, and wherever else they occur, are not individualized. They are timeless, mythic images of generic humans, not portraits of specific, historical individuals.

All the while Westerners are adding emotion and individuality to the faces in Indian art, which has the effect of locating the images in time as well, we deny these qualities to the Indians themselves, holding on to old stereotypes of *people locked into their past* and cultures without viability in our urban, industrial society.[3] *This is the crux of the matter,* writes Thomas Berger, Canada's champion of Native rights: *Our attitude has been founded on the belief that native society is moribund, that their "culture" consists of crafts and carvings, dances and drinking—that it is at best a colourful reminder of the past, and that what we observe today is no more than a pathetic and diminishing remnant of what existed long ago.* But Native people do not wish to return to the past, nor to be *objects of mere sentimentality. They do not say that native culture, native communities and the native economy should be preserved in amber for our amusement and edification. Rather, they wish to ensure that their culture can continue to grow and change—in directions they choose for themselves.*[4]

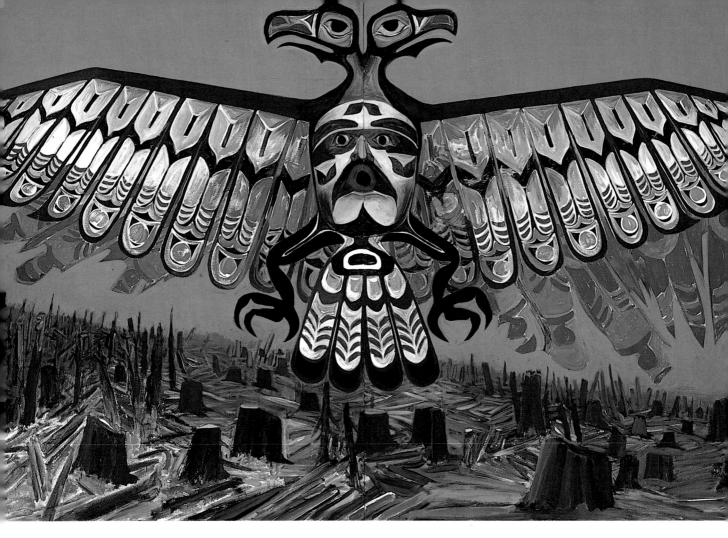

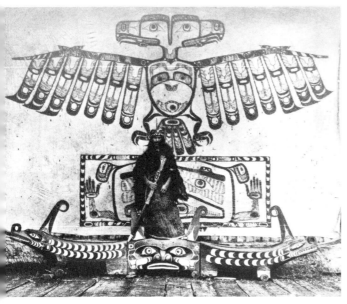

Figures 47, 48. **Elegy for an Island**, 1985, and a Southern Kwagiutl ceremonial curtain. Photograph of the painting courtesy the Vancouver Art Gallery: the Edward S. Curtis photograph of the curtain courtesy the British Columbia Provincial Archives, No. HP74554.

Figure 49. **Storm Warning**, 1986, is an abstract expression of yellow anger, floating over a forest of stumps. It was painted after **Elegy for an Island.**

The museum fetish of context, according to which it is immoral and perverse to exhibit Native material in ways that imply any purpose other than the one for which we assume it was first developed, has given us little opportunity to appreciate cultural interpenetrations involving European and Native traditions. Indeed, museums have contributed significantly to the notion that Indian cultures are frozen in past time and unchanging. Contemporary Indian art has been exhibited so far almost exclusively as continuous with nineteenth-century Native culture, thus suppressing the role European-derived media and techniques have played in its evolution. Bill Reid, for example, studied European jewellery making at the Ryerson Polytechnical Institute in Toronto, and Robert Davidson studied print making at the Emily Carr College of Art and Design in Vancouver.

The new attitude of respect for Native forms in Shadbolt's paintings suggests that our attitudes are changing, and it coincides with a new political will in Indian society. In late 1984, the Nuu-chah-nulth people of the west coast of Vancouver Island took a stand in opposition to the logging of Meares Island, one of their traditional territories, and gained an injunction to halt it, though only temporarily. *One canvas from the winter*, writes Shadbolt in his journal (p. 45), *took off from the Meares Island logging controversy—an unusually direct political statement for me since my very early days as a young artist. Yet still in all these works I am trying to say what I have to say in poetic rather than literal terms.* He is referring to **Elegy for an Island** (figure 47) a large figurative and forcefully stated painting in which a giant double-headed eagle hovers over a forest of stumps, its talons ready for some unseen prey, astonishment on its stomach/face.

The Nuu-chah-nulth were followed by the Haida, some seventy-two of whom were arrested when they formed human blockades in order to prevent logging on Lyell Island in the Queen Charlottes. Whereas in the past, the *refusal to be assimilated was passive, even covert*, writes Berger, *today it is plain and unmistakable, a fact of life that cannot be ignored.*[5]

The new tribal leaders are not only preparing well-researched legal briefs to argue for aboriginal rights under the new Canadian Constitution: they are also using the media in sophisticated ways to assert the morality of their claims and the continuing viability of their culture. As Berger notes, *Native people insist that their culture is still a viable force in their lives. It informs their view of themselves, of the world about them, and of the dominant white society.... Their tradition of decision making by consensus, their respect for the wisdom of their elders, their concept of the extended family, their belief in a special relationship with the land, their regard for the environment, their willingness to share—all these values persist in one form or another within their own culture, even though there has been unremitting pressure to abandon them.*[6] As if in response to Atwood's statement at the head of this section, Berger concludes his 1983 article arguing that *it is, in fact, in our relations with the people from whom we took this land that we can discover the truth about ourselves and the society we have built, and gain a larger view of the world.*

Art is the practice of proposing alternate models of reality, Jack Shadbolt said in a 1985 speech at a rally in support of the arts in Canada. This is, of course, not only a political statement, but a radical and even a subversive one. *Art constructs models of possible realities*, he continued: *It keeps the edge of our consciousness sharp. It stands for self-realization and self-naming. It is a noble concept—the very foundation of a democratic society.* He went on to argue that art is the process by which three levels of experience combine: the senses, by which we know the realities and delights and pains of existence; the mind, by which we reason and calculate and construct; and the feelings,

which deal with our emotional and spiritual states. *The art process is the core act of fusion where these elements are resolved in the deep psyche and are projected through mental images which are our metaphors for our insights into the human condition.*

At the same rally, Robert Davidson said: *Over the years I've been demonstrating carving and people have always come up to me and accused me of coming from such a rich culture. I always fire back by saying that "you come from a rich culture also."* He continued, with delicious irony: *So I'd like to verbalize my support in your fight to have your culture survive for the next few years,* then concluded by echoing Shadbolt with a statement about the importance of art in the assertion of community: *The art is an expression of the time... it comes from a philosophy of the people, and it defines the people. For us, the art is defining our people once again. We are now gaining strength and now are part of the world, and I'd like to see Vancouver and Canada be part of the world also... be part of the artistic world.*

The problem of cultural integration, writes Clifford Geertz, *becomes one of making it possible for people inhabiting different worlds to have a genuine, and reciprocal, impact on one another.* If we are to produce genuine culture, it will consist of the *interplay of a disordered crowd of not wholly commensurable visions.* The vitality of modern consciousness, Geertz believes, *depends upon creating the conditions under which such interplay will occur.*[7]

Interplay is a good word for the phenomenon we have been examining. Jack Shadbolt's paintings and Indian art cannot be explained in terms of each other; they are not "commensurable visions," but they interact or interplay in ways that shed light on our social and cultural relations with each other. The new autonomy of Indian forms in Shadbolt's paintings, and the respect I read in them, are appropriate expressions of the changing attitudes of British Columbians to the Native society in our midst, and for the new political will Native people are now manifesting. Their demands for fair settlement of their land claims and local self-government will be met by the dominant society only out of a respect for cultural autonomy such as Jack Shadbolt is now revealing to us. *It is my conviction,* writes Berger, *that if in working out a settlement of native claims, we try to force native social and economic development into moulds that we have cast, then the whole process will be a failure.*[8]

The fact that Jack Shadbolt has not been in the vanguard of political consciousness on Indians, and that he does not create Indian paintings to promote an ideological point of view, makes his 1985-86 paintings all the more significant as social statements. It is my impression that he was actually surprised to see what he had painted in **Elegy for an Island.** For the forty years during which he has been practising the entranced manner of painting that he calls the *act of art,* he has been expressing rather than manipulating life's programming. In the belief that he was expressing himself, he has been expressing us as well.

Culture, in the anthropologist's formulation, is the patterning of behaviour we share with others with whom we live in community. In his maturity as an artist, Jack Shadbolt has mastered the ability to reach deep into himself to produce socially significant images. To paraphrase the novelist James Joyce, he is forging in the smithy of his soul the uncreated conscience of the race.

1. Margaret Atwood 1972:104.
2. for example, Jonathan King 1979.
3. Thomas Berger 1983:14.
4. Berger 1983:13, 18.
5. Berger 1984:14.
6. loc. cit.
7. Clifford Geertz 1983:161.
8. Berger 1983:21.

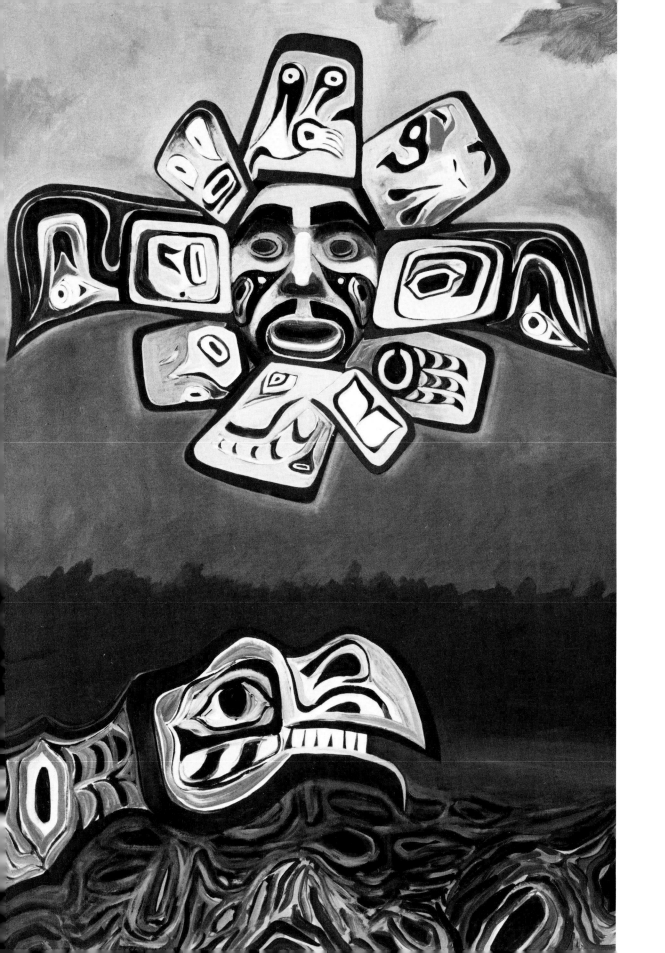

Entry from Jack Shadbolt's journal, 9 July 1985

Because of the forthcoming exhibition of my Coast Indian-related paintings the theme of my relationship to their mythology keeps surfacing in my mind. I have done three recent works, each in a 5-ft.-square format, each with a floating configuration derived from masks or ceremonial headgear over a land or sea context: **Grieving Spirit, Sea Legend** *(this painting is not reproduced) and* **The Valley Beyond.** *The titles are tentative but somehow they fixed themselves in my mind as the images neared completion; and titles seem significant in this ambience of the Indian world.*

Without having given it too much logical thought I begin to notice, now, that all the recent works I have done since this show was first suggested to me have themes of pungent commentary about the Coast Indian civilization and its problems of survival and decline, in addition to my usual previous more lyrical or poetic involvement with ritual and transformation. Lately (and partly, I suppose, because of continuous discussion with Doris during the working out of her ideas for her book on Bill Reid), I begin to reconsider the Indian society, somewhat in the same spirit as Emily Carr at times, as a wounded civilization—a last stand of indigenous mythic values coloring the background of our native landscape. One canvas from the winter took off from the Meares Island logging controversy—an unusually direct political statement for me since my very early days as a young artist. Yet still, in all these works I am trying to say what I have to say in poetic rather than literal terms. They seem genuinely enigmatic to me, generalized rather than specific yet

Figure 50. **Waiting,** 1986. When a 1971 painting entitled **Coast Indian Memory** could not be located, Shadbolt painted this one, from a slide of the earlier work, to take its place in the exhibition.

more commentative than the totem transformation series which were dealing with the concept of transformation itself from Indian symbolic suggestion into contemporary abstraction: whereas in the recent group the emphasis is on the expressive pathos of the image itself, all three implying human connotations, though the subjects of **Sea Legend** *are whales.*

What am I trying to say? I don't know, quite. About the suffering aspect of seeing a powerfully poetic social symbology going down the drain of history? About the pathos and often tragedy of individual displacement from a symbolic past into a bleak new reality? About the drama of the whole entropic situation? About our envy, nevertheless, of the primitive purity that once was theirs—and their dignity within their own world and what we have forced them into? All these aspects roll through my consciousness as I get immersed in this working out of my relationship to all of this, in seeing it in artistic terms as the stuff of poetry, of legend making, without need to justify its literal authenticity, as distanced by time and filtered through my response to the "museum without walls" of a cultivated Western artist. The results are as baffling to me as my images may be to the Indians who may either find a chord of recognition or an outrage at my seemingly detached arrogance. They cannot, however, I think, feel that I am unsympathetic, and I am sure I am not more emotionally detached than those of the new generation of Indian artists who are using their own traditional stylistic images for purely dramatic or decorative purposes.

Whatever of such speculations may be engendered by this non-Indian response to the Indians' spiritual and historic presence in our environment I realize that I myself will be the greatest learner from this exhibition.

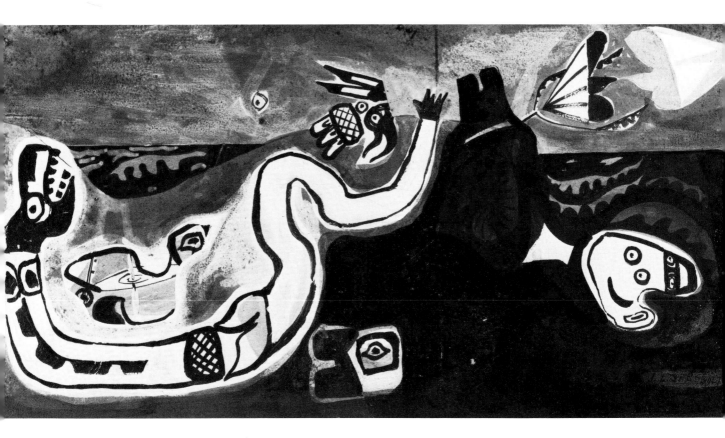

Figure 51. **Legend,** 1957. This little painting is a good example of Shadbolt's "generalized primitivism" of the 1950s. While a practised eye can detect coastal Indian motifs, these are incidental.

Lenders to the Exhibition

Richard and Linda Alexander, Vancouver

Mr. and Mrs. Howard Isman, Vancouver

Dr. Ben Kanee, Vancouver

Mr. John McDonald, Vancouver

Doris Shadbolt, Burnaby

Jack Shadbolt, Burnaby

Art Gallery of Greater Victoria

British Columbia Provincial Museum, Victoria

The Canada Council Art Bank, Ottawa

Milwaukee Public Museum

National Museum of Man, Ottawa

Portland Art Museum

Vancouver Art Gallery

and other private lenders

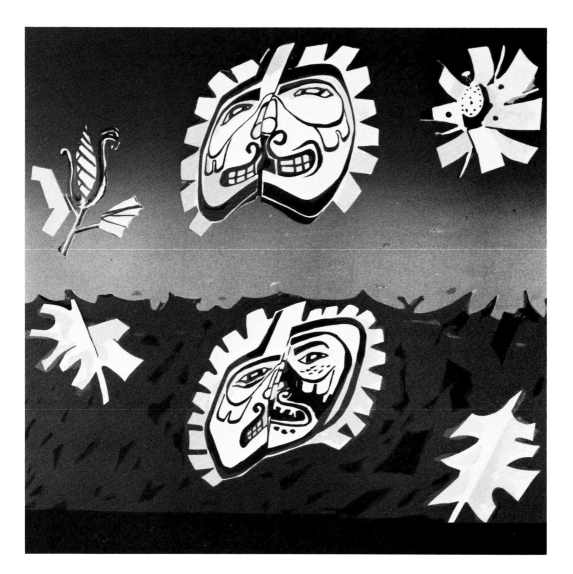

Figure 52. **Risen Sun**, 1986. Serigraph print,
50.0 x 51.0 cm. Yellow, black, brown, khaki,
gold, white, and blue. Edition of 65. This
print is based on the painting of the same
name (figure 21). Print not exhibited.

Paintings in the Exhibition

Indian Village
1948
oil on board
76.0 x 101.0 cm
Vancouver Art Gallery

Red Knight
1947
oil and lucite on paper
76.2 x 53.3 cm
private collection

Bird Skeleton
1948
carbon on paper
57.8 x 40.0 cm
Doris Shadbolt

Killer Birds
1948—study
carbon and watercolour on paper
46.7 x 37.2 cm
Dr. Ben Kanee

Killer Birds
1948
carbon and watercolour on paper
37.0 x 48.0 cm
Dr. Ben Kanee

Sea Cave
1948
carbon and watercolour on paper
38.0 x 43.0 cm
private collection

Coast Indian Theme
1952
sanguine and sepia on paper
38.0 x 48.0 cm
John McDonald

Variation on a Coast Indian Theme
1956
mixed media
71.5 x 92.0 cm
Richard and Linda Alexander

Legend
1957
watercolour on paper
21.6 x 38.1 cm
private collection

Risen Sun
1964
ink and watercolour on paper
61.0 x 66.0 cm
collection: the artist

Guardian Spirit of Owl
1971
acrylic and ink on board
152.4 x 101.6 cm
private collection

The Place
1972
watercolour and conté on board
three (152.4 x 101.6 cm) panels
on loan from the Canada Council
Art Bank/Prêt de la Banque
d'oeuvres d'art du Conseil
des Arts du Canada

Guardian
1972
ink, latex, crayon, acrylic on paper
152.4 x 101.6 cm
private collection

Coast Indian Suite
1976
charcoal and crayon on board
twenty (152.4 x 101.6 cm) panels
private collection

Variation on a Kwakiutl Ghost Mask
1976
charcoal and crayon on board
152.4 x 101.6 cm
Mr. and Mrs. Howard Isman

Into Totem
1982
acrylic on canvas
144.8 x 106.8 cm
collection of the Art Gallery of Greater Victoria

Coast Memory IV
1982/85
acrylic on canvas
122.5 x 152.4 cm
collection: the artist

Toward Totem
1982/86
acrylic on canvas
175.6 x 124.8 cm
collection: UBC Museum of Anthropology

Pisces
1985
acrylic on canvas
155.0 x 120.0 cm
collection: the artist

Elegy for an Island
1985
acrylic on canvas
145.0 x 213.0 cm
Vancouver Art Gallery

Bird Spirit
1985
acrylic on canvas
152.4 x 101.6 cm
collection: the artist

Silent Land
1985
acrylic on canvas
three (152.4 x 122.0 cm) panels
Vancouver Art Gallery

Grieving Spirit
1985
acrylic on canvas
160.0 x 145.0 cm
collection: the artist

The Valley Beyond
1985
acrylic on canvas
154.5 x 154.5 cm
collection: the artist

Drum Song
1986
acrylic on canvas
124.0 x 170.0 cm
collection: the artist

Storm Warning
1986
acrylic on canvas
170.0 x 124.0 cm
collection: the artist

Waiting
1986
ink and watercolour on board
152.4 x 101.6 cm
collection: the artist

Artifacts in the Exhibition

Southern Kwagiutl Hamatsa Ghost Mask
before 1915
wood, cedar bark, cloth
red, green, black
34.0 x 21.5 x 13.5 cm
Milwaukee Public Museum 17325

Bella Coola Echo Mask with "Mouth of the
 Rock" attachment
before 1915
wood
blue, red, black
35.5 x 24.5 x 20.5 cm (mask)
30.0 x 14.0 x 9.5 cm (mouth attachment)
Milwaukee Public Museum 17348, 17349

Tlingit Raven Mask
before 1931
wood, leather, sinew
red, green
30.2 x 22.2 x 17.8 cm
Rasmussun Collection of Northwest Coast
 Indian Art, Portland Art Association
Portland Art Museum 48.3.393

Tlingit Wolf Dance Hat
late nineteenth century
wood, skins, teeth, shell, hair
blue-green, red, yellow, black
61.0 x 41.3 x 21.6 cm
National Museum of Man VII A 320a, b

Bella Bella Transformation Mask
before 1879
wood, copper, hair, canvas
black, white, red, green
100.3 x 82.6 x 35.6 cm (open)
National Museum of Man VII B 20

Haida Tambourine Drum
before 1900
hide, gut, wood
red, black, white
62.4 x 62.4 x 9.0 cm
British Columbia Provincial Museum 10630

Southern Kwagiutl Sun Mask
before 1913
wood, twine, leather
green, red, black, white, brown
75.0 x 67.0 x 35.0 cm
British Columbia Provincial Museum 1908

Southern Kwagiutl Echo Mask with Echo
 mouth attachment
before 1914
wood, hair
green, black, white, blue, red
31.5 x 27.5 x 14.0 cm (mask)
17.5 x 17.7 x 8.0 cm (mouth attachment)
British Columbia Provincial Museum 13495 a,f

Southern Kwagiutl Numahl Mask
before 1911
wood, copper, hair
red, black, white
32.2 x 25.2 x 22.3 cm
British Columbia Provincial Museum 1867

Western Grebe Skeleton
45.7 cm high, articulated
British Columbia Provincial Museum 1038

Southern Kwagiutl Atlakim Mask
1950
wood, cedar bark
white, red, black
22.7 x 20.3 x 10.2 cm
UBC Museum of Anthropology A4163

Southern Kwagiutl Sun Mask
before 1918
wood, leather, cloth, string
black, green, red, white
72.4 x 59.7 x 35.6 cm
UBC Museum of Anthropology A3553

Southern Kwagiutl Sun Mask
before 1973
wood
black, green, red, yellow, white
73.7 x 72.4 x 24.5 cm
UBC Museum of Anthropology A17141

Haida Bent Box
before 1920
wood
red, black
33.7 x 33.7 x 42.5 cm
UBC Museum of Anthropology A8435

Southern Kwagiutl Hamatsa Raven Mask
1952
wood, cedar bark, feathers
red, white, black
104.1 x 30.5 x 25.4 cm
UBC Museum of Anthropology A4243

Southern Kwagiutl Hamatsa Raven Mask
before 1904
wood, cedar bark, feathers
red, white, black
91.4 x 30.5 x 30.5 cm
UBC Museum of Anthropology A3673

Kwagiutl Dsonoqua
before 1982
wood
122.0 x 74.0 x 21.0 cm
UBC Museum of Anthropology 851/10

Artifacts and Paintings Illustrated but not Exhibited

Strangled by Growth
Emily Carr
1931
oil on canvas
63.5 x 48.3 cm
Vancouver Art Gallery

Indians Outside a Village
1944
carbon and watercolour on watercolour paper
35.0 x 44.0 cm
private collection

House at the End
1946
brush, ink
owner: unknown

Dog Among the Ruins
1947
watercolour, carbon pencil
78.2 x 56.9 cm
collection: Art Gallery of Greater Victoria

Victim
1947
watercolour, ink
48.5 x 38.7 cm
collection: National Gallery of Canada

Image with Red Bones
1947
oil on watercolour board
76.2 x 54.3 cm
owner: unknown

Kwagiutl Sneezer Mask
before 1953
wood, nails, cedar bark
red, brown, black, white
35.8 x 23.7 x 18.6 cm
UBC Museum of Anthropology A6214

Indian Mask (Drawing)
1939
carbon pencil, sanguine
56.0 x 69.0 cm
collection: John McDonald

Tsimshian Charm with Pendants
ivory
13.9 x 17.7 cm
National Museum of Natural History 89021
Smithsonian Institution

Kwagiutl Transformation Mask
before 1933 (?)
wood, cedar bark
white, red, black, yellow, green
65.9 x 89.6 cm (open)
Rasmussen Collection of Northwest Coast
 Indian Art
Portland Art Museum 48.3.408

Risen Sun
1986
serigraph
50.0 x 51.0 cm

The Charmed
1986
serigraph
27.0 x 70.5 cm

Tlingit Hat with Whale Crest
1925
woven spruce root, wood, shell inlays, human
 hair, fibre lashings, rawhide strap
black, white, red, green
36.2 cm diameter
acquired from the Sitka Whale House
 collection by Louis Shotridge
University Museum, Philadelphia NA10512

Kwagiutl Killerwhale on Sun Mask
1915
wood and cloth
green, blue, red, white, black
68.5 cm diameter, 94.0 cm total height
The Samuel A. Barrett Collection
Milwaukee Public Museum 17321

Thunderbird Mask (opens to reveal Sisiutl)
1915
wood
green, red, white, black
48.3 cm (length when closed)
The Samuel A. Barrett Collection
Milwaukee Public Museum 17379

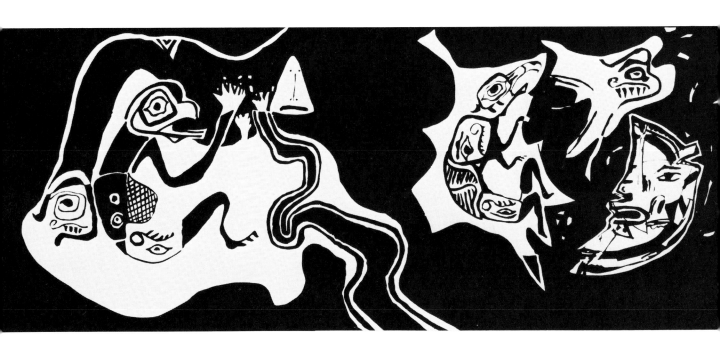

Figure 53. **The Charmed**, 1986. Serigraph
print, 27.0 x 70.5 cm. Gold, black, and white.
Edition of 100. Print not exhibited.

Bibliography

Atwood, Margaret. 1972. **Survival: A Thematic Guide to Canadian Literature.** Toronto: Anansi.

Berger, Thomas R. 1983. *Native History, Native Claims and Self-Determination,* in **BC Studies** 57.

Burridge, Kenelm. 1979. **Someone, No One: An Essay on Individuality.** Princeton: Princeton University Press.

Davidson, Robert. 1985. *I hope your culture survives for the next few years,* in **The State of the Arts.** Published for the B.C. Coalition for the Arts by the Assembly of B.C. Arts Councils, Vancouver.

Donoghue, Denis. 1983. **The Arts Without Mystery.** (The 1982 Reith Lectures in Expanded Form.) London: BBC.

Duff, Wilson. 1975. **Images Stone BC.** Saanichton, B.C.: Hancock House.

Geertz, Clifford. 1983. **Local Knowledge.** New York: Basic Books.

Frye, Northrop. 1982. *Culture as Interpenetration, in* **Divisions on a Ground: Essays on Canadian Culture.** Toronto: Anansi.

Gibson, Ann. 1983. *Painting Outside the Paradigm: Indian Space,* in **Arts Magazine,** New York, March.

Hawthorn, H.B., C.S. Belshaw, and S.M. Jamison, 1958. **The Indians of British Columbia.** Toronto: University of Toronto Press.

King, J.C.H. 1979. **Portrait Masks from the Northwest Coast of America.** London: Thames and Hudson.

Lindberg, Ted. 1978. **Jack Shadbolt: Seven Years.** Vancouver: Vancouver Art Gallery.

Lowndes, Joan. 1981. *Metamorphosis and Metaphor: Jack Shadbolt,* in **Vanguard** (Vancouver Art Gallery) 10 (2).

Rose, Bernice. 1980. **Jackson Pollock: Drawing into Painting.** New York: Museum of Modern Art.

Rubin, William. 1984. *Picasso,* in William Rubin, ed., **Primitivism in 20th Century Art.** New York: Museum of Modern Art.

Schapiro, Meyer. 1978. *Nature of Abstract Art,* in **Modern Art: 19th and 20th Centuries: Selected Papers.** New York: Braziller.

Shadbolt, Doris. 1979. **The Art of Emily Carr.** Toronto and Vancouver: Clarke, Irwin/Douglas & McIntyre.

Shadbolt, Jack. 1968. **In Search of Form**. Toronto and Montreal: McClelland and Stewart.

1975. *The Activity of Art: A personal response to history,* in **artscanada** 32(2).

1981. **Act of Art.** Toronto: McClelland and Stewart.

1985. *People need the Arts,* in **The State of the Arts**. Vancouver: B.C. Arts Councils.

Staal, Frits. 1979. *The Meaningless of Ritual,* in **Numen** 26 (1).

Tamlin, Illi-Maria. 1984. **Jack Shadbolt: Cross Cultural Notations.** Peterborough, Ont.: Art Gallery of Peterborough.

Tennant, Paul. 1983. *Native Political Activity in British Columbia, 1969-1983,* in **BC Studies** 57.

Thom, Ian M. 1980. **Jack Shadbolt: Early Watercolours.** Victoria: Art Gallery of Greater Victoria.

Varnedoe, Kurt. 1984. *Abstract Expressionism,* in William Rubin, ed., **Primitivism in 20th Century Art.** New York: Museum of Modern Art.

Vickers, Roy. 1977. *Introduction,* **Northwest Coast Indian Artists Guild 1977 Graphics Collection.** Ottawa: Canadian Indian Marketing Services.

Watson, Scott. 1985. **Jack Shadbolt: Act of Painting.** Vancouver: Vancouver Art Gallery.

Wentinck, Charles. 1978. **Modern and Primitive Art.** Oxford: Phaidon.

Woodcock, George. 1973-4. '*... the long echo is answered': The paintings of Jack Shadbolt,* in **artscanada** 30 (5 & 6).

Worringer, Wilhelm. 1953. **Abstraction and Empathy,** Michael Bullock, trans. London: Routledge and Kegan Paul. (First published in German in 1908.)

Zervos, Christian. 1952. *Conversation with Picasso,* in Brewster Ghiselin, ed., **The Creative Process.** Berkeley: University of California Press (reprinted by Mentor Books, Scarborough, Ont.).

Photo Credits:

Acknowledgements

The one quality on which the successful production of both books and exhibitions depends is generosity—not only by the owners, both public and private, of cultural properties, but also by funding organizations and individuals, curators, registrars, museum and gallery directors, editors, archivists, registrars, conservators, shippers, customs officials, designers, printers, administrative staffs, bookkeepers, photographers, and, especially in this instance, by students. Cultural production is the work of busy professionals, people whose commitment and willingness to serve is not a matter of purchase, but gifts freely given, gifts which in most cases require the reorganization of their own priorities.

For their willingness to help me and my colleagues at the Museum of Anthropology produce this book and exhibition, I thank the following people and the institutions they represent: Kitty Bishop Glover, Tom Govier, and Andrea Laforet of the National Museum of Man; Tara Douglas of the Museum Assistance Programmes, National Museums of Canada; Kevin Neary, Alan Hoover, Peter Macnair, Dan Savard, and Geoff Stewart of the British Columbia Provincial Museum; Barbara McLennan of the Provincial Archives of British Columbia; Dennis Cardiff and Will Kirby of The Canada Council Art Bank; Scott Watson and Jim Gorman of the Vancouver Art Gallery; Amy Algard, Janette Barr, Patricia Bovey, and Nicholas Tuele of the Art Gallery of Greater Victoria; Kathryn Gate and Gwen Putnam of the Portland Art Museum; Claudia Jacobson and Nancy Oestreich Lurie of the Milwaukee Public Museum; Andy Andrejicka, Herb Sigman, and Xisa Huang of the Bau-Xi Galleries; Sheila Aistrich and Valerie Schauble of ProCreations Publishing Corp.; Ken Stephens of Denbigh Design; Robert E. Dubberley of the Vancouver Centennial Commission; Barry Spillman of the Department of Communications; Robert F. Will of the University of British Columbia Faculty of Arts; Brian Scrivener and Richard Howard of UBC Press; Sandra Hawkins and Susan Holt of UBC Printing and Copying Services; and Robert Keziere, Photographer.

I also thank the private lenders to the exhibition—those whose ownership is acknowledged, those who prefer to remain anonymous, and those others whose paintings were requested and offered, but for reasons of space could not be displayed.

Only Susan Hull, Susan Kilpatrick, Beth Carter, Evelyn Legare, and Jacquie Gijssen, students who worked with me on the many details of the exhibition and publication, know how much assistance I needed, but they will probably never know how much I counted on their help and how grateful I am for it.

My personal rewards from organizing the exhibition and writing this book have been many and there are more to come, but the one for which I am most grateful has been the opportunity it gave me to enjoy the friendship of Jack and Doris Shadbolt. Not only have they shared their lives in art with me, but their demonstration that life itself is an art to be cultivated and enjoyed with dignity and graciousness is one that I once learned from my dear Aunt Margaret and had forgotten.

Finally, I thank the friends and colleagues whose conversation and affection feed me constantly, and who will recognize their contributions herein: Michael Ames, Glenn Allison, Laurie Moss, Nathalie Macfarlane, and Carole Farber.

Marjorie M. Halpin
June 1986

Figure 54. The Tlingit Hat with Whale Crest that appears in Panel 2 of **Coast Indian Suite** (fold-out figure 57). Hat not exhibited, photograph courtesy of the University Museum, Philadelphia.

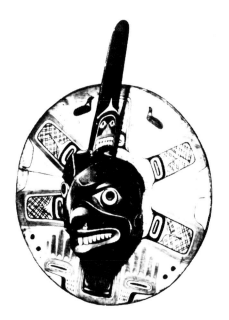

Figure 55. The Kwagiutl Killerwhale with Sun Mask that appears in Panel 7 of **Coast Indian Suite** (figure 57). Mask not exhibited; photograph courtesy the Milwaukee Public Museum.

Figure 56. The Kwagiutl Transformation Mask that appears in Panels 16 and 17 of **Coast Indian Suite** (figure 57). Mask not exhibited; photograph courtesy the Milwaukee Public Museum.

Figure 57. **Coast Indian Suite,** 1976. Source images for the artifacts in this painting are the following publications: Panel 1, Deerskin War Shirt (Chilkat?), Erna Siebert and Werner Forman, 1967, **North American Indian Art**, plate 96; Panel 2, Tlingit Ceremonial Hat, Henry B. Collins et al., 1973, **The Far North**, plate 255; Panel 3, (small skeletal figure in lower left), Siebert and Foreman, plate 107; Panel 4, unknown; Panel 5, Tlingit Shaman's Spirit Mask, Henry B. Collins et al., plate 298; Panel 6, Ceremonial Headdress, Siebert and Foreman, plate 28; Panel 7, Kwagiutl Family Crest Mask, Robert Ritzenthaler and Lee A. Parsons, eds., 1966, **Masks of the Northwest Coast,** plate 50; Panel 8, Tlingit Wolf Forehead Mask, Henry B. Collins et al., plate 262; Panel 9, Tlingit Halibut Hook, Henry B. Collins et al., plate 361; Panels 10 and 11, Kwagiutl Transformation Mask, Norman Feder, 1971, **Two Hundred Years of North American Indian Art,** plate 44; Panel 12, Kwagiutl Frontlet Headdress, Feder, plate 24; Panel 13, Kwagiutl Echo Mask, Feder, plate 23; Panel 14, Tlingit Raven Mask, Henry B. Collins et al., plate 304; Panel 15, Haida Beaver Bowl, Feder, plate 49; Panels 16 and 17, Kwagiutl Thunderbird Mask, Ritzenthaler and Parsons, plate 32; Panel 18, carving of animal with human hands and face, Siebert and Foreman, plate 74; Panel 19, Bella Coola Echo Mask, Ritzenthaler and Parsons, plate 38; Panel 20, adze handle, Feder, plate 9. Photographs courtesy of the Bau-Xi Gallery, Vancouver.

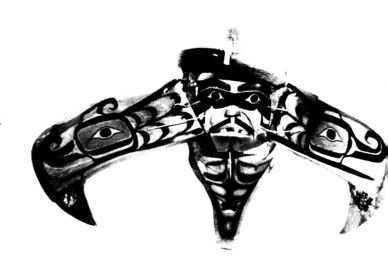